MINDFULNESS
COLORING BOOK

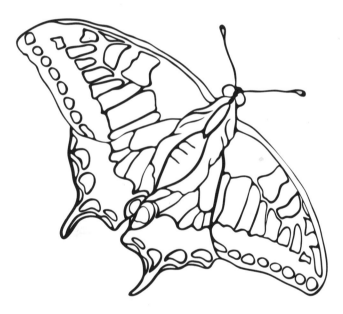

MINDFULNESS
COLORING BOOK

CHARTWELL
BOOKS

This edition published in 2015 by
CHARTWELL BOOKS
an imprint of Book Sales
a division of Quarto Publishing Group USA Inc.
142 West 36th Street, 4th Floor
New York, New York 10018
USA

Copyright © Arcturus Holdings Limited
26/27 Bickels Yard, 151–153 Bermondsey Street,
London SE1 3HA

ISBN: 978-0-7858-3369-7
CH004877NT

Printed in China
Reprinted 2016

Introduction

In today's stressful world we are increasingly looking for ways to help us unwind. Coloring is a fantastic relaxation technique for adults. It takes the brain to a peaceful place of focus and creativity, and helps you to enter a freer state of being.

The *Mindfulness Coloring Book* contains a wealth of mandalas and other calming images to soothe the mind and please the senses. By coloring in these designs you will de-stress your mind and body and create your own beautiful artwork. So put your worries on hold, pick up your crayons, pencils or felt-tips, and let those feelings of tranquility and contentment wash over you!

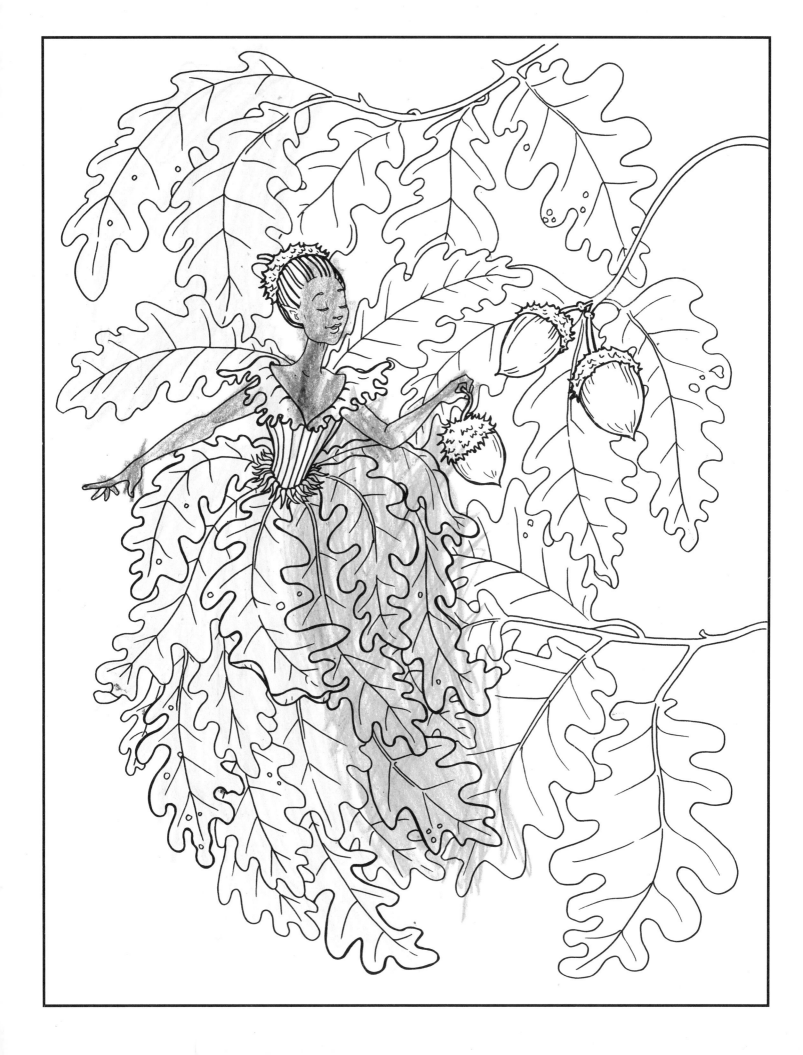

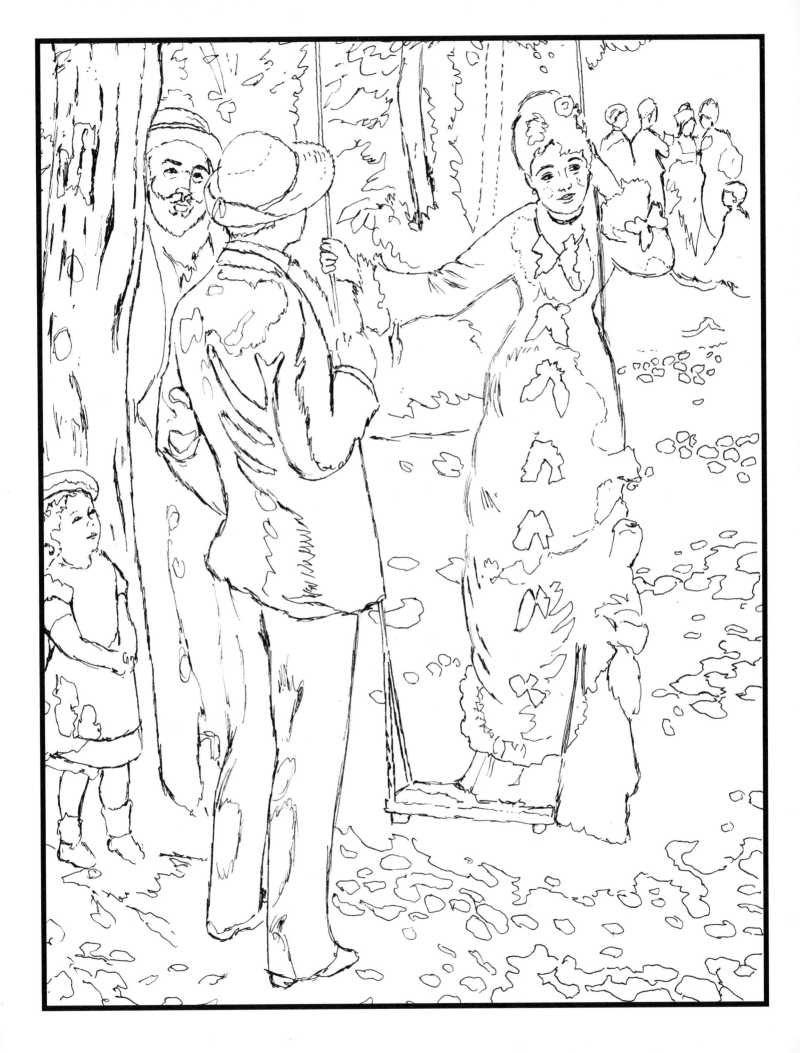

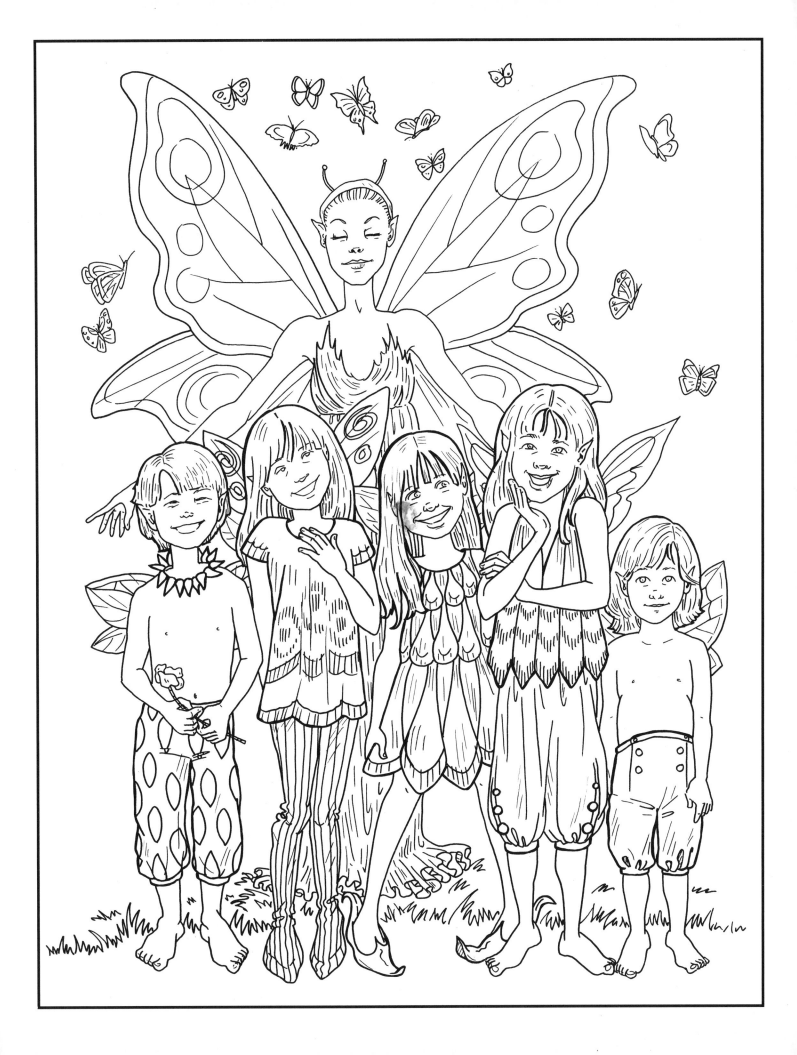

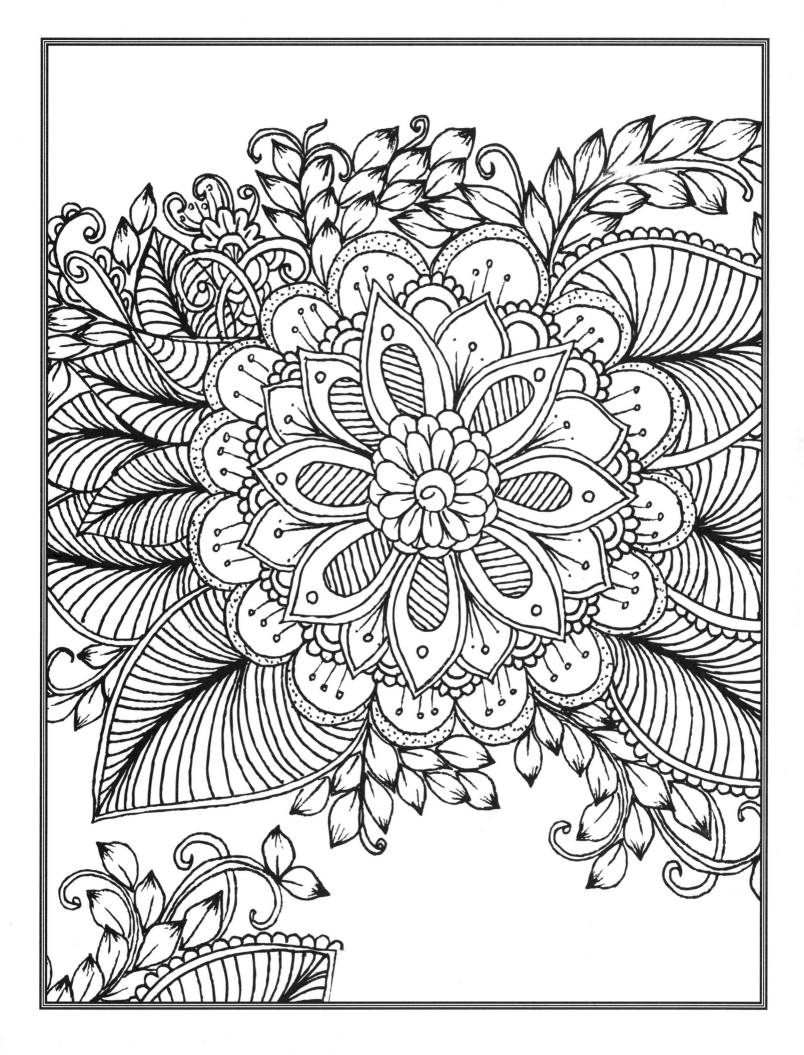

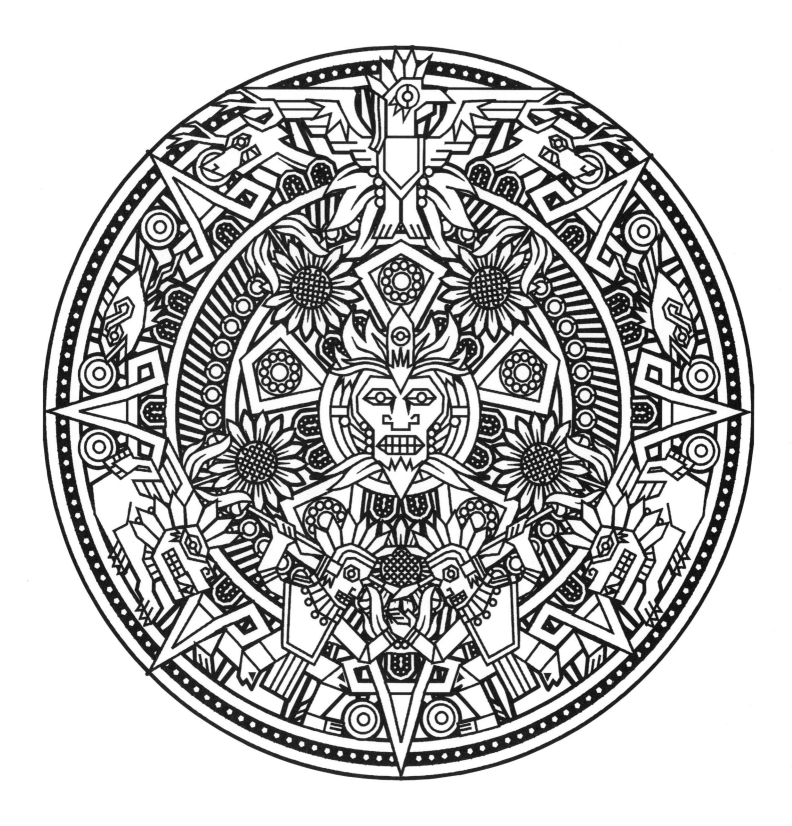

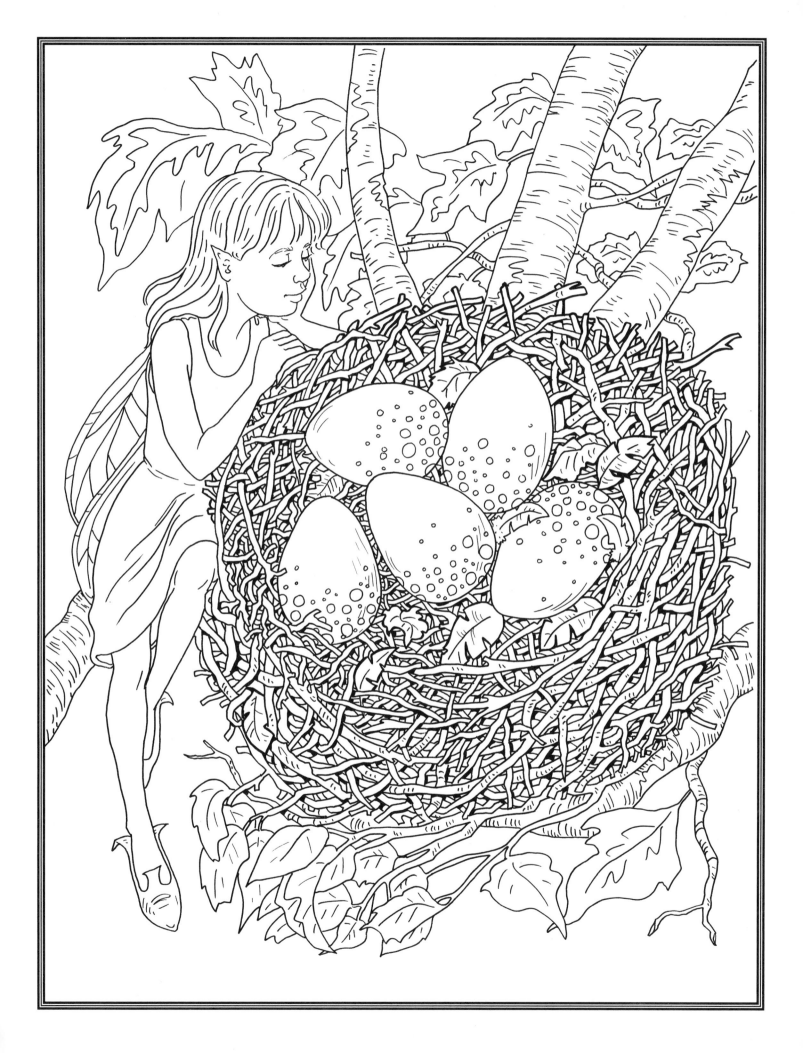

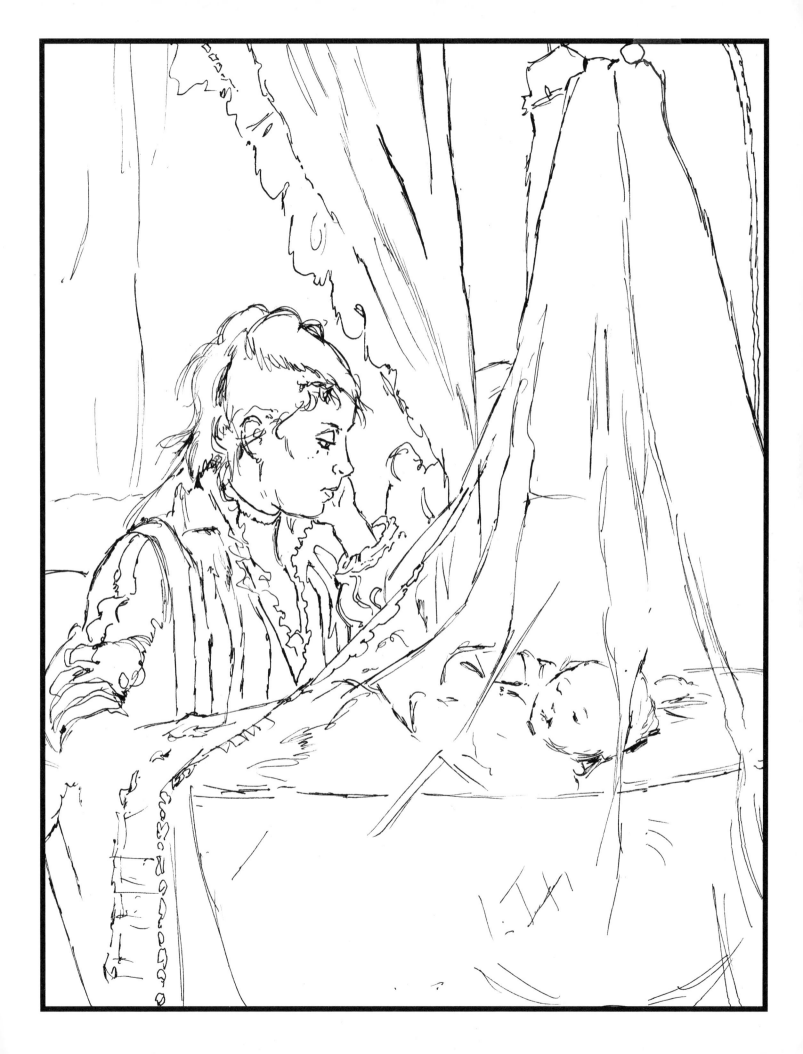

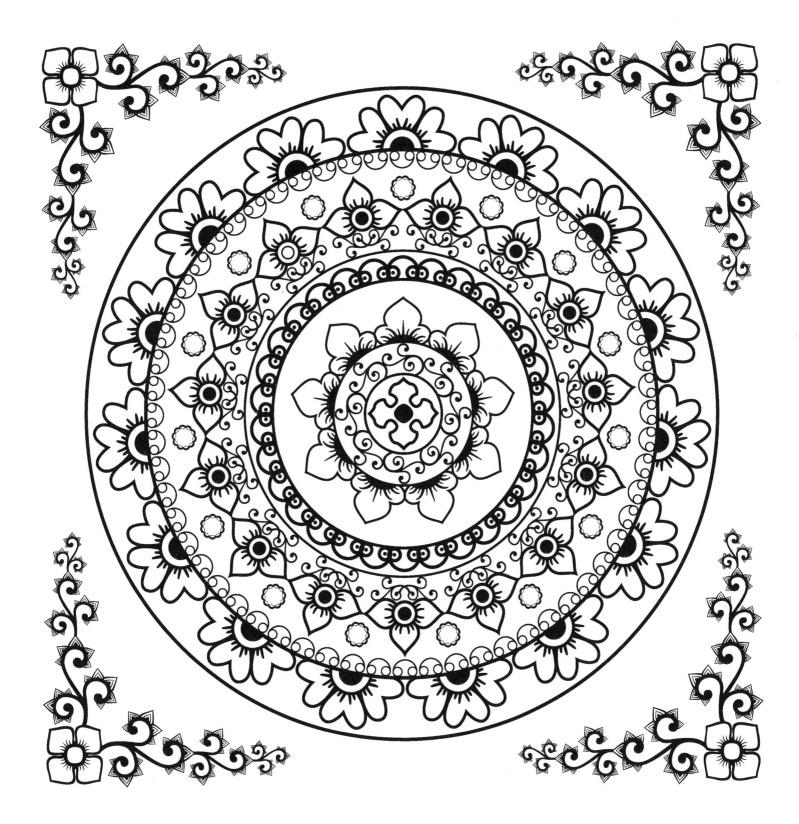

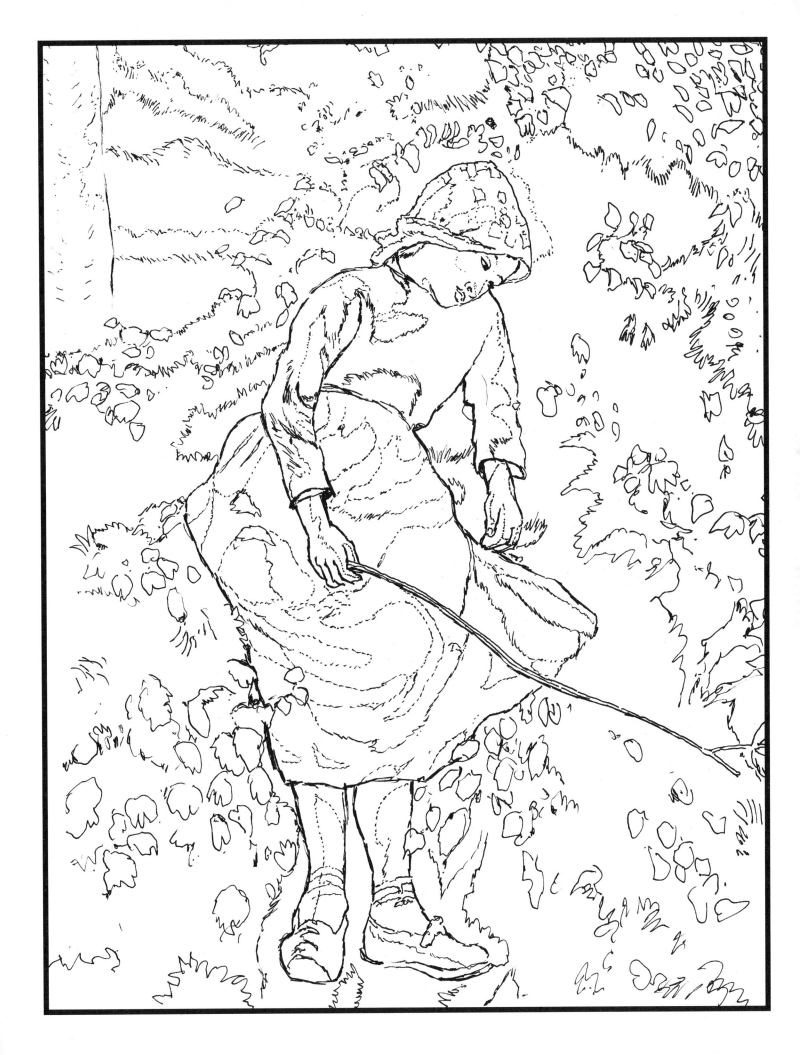

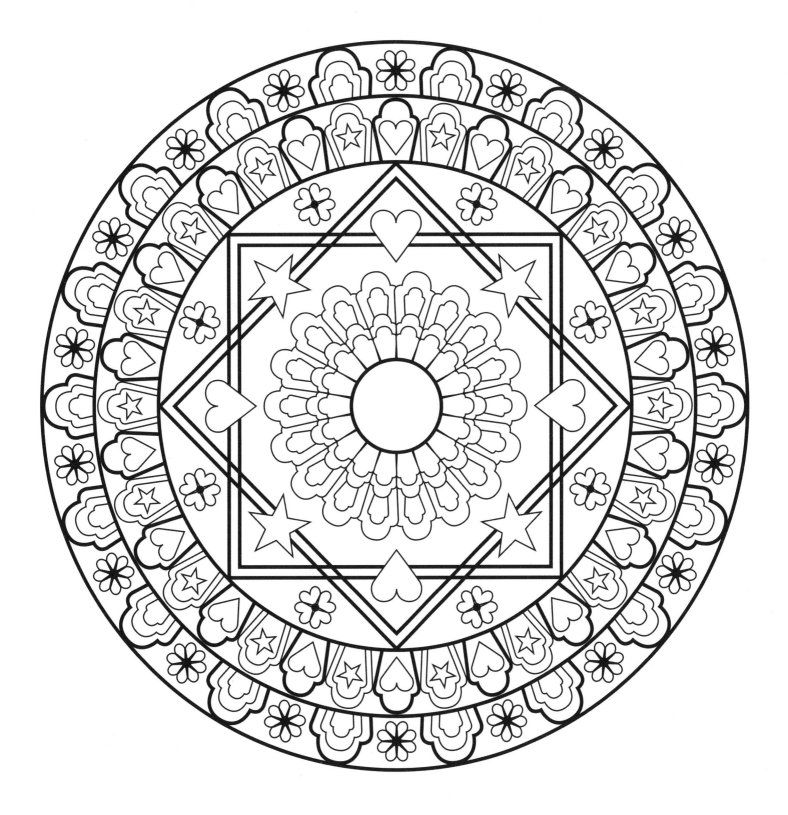

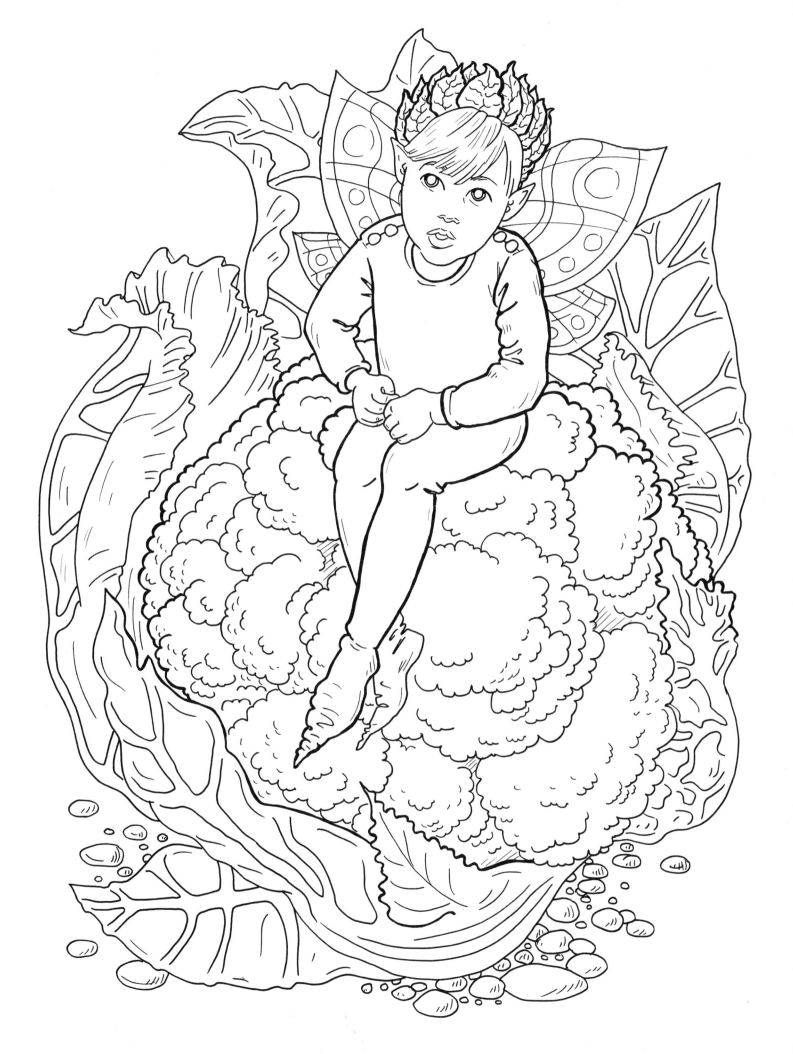

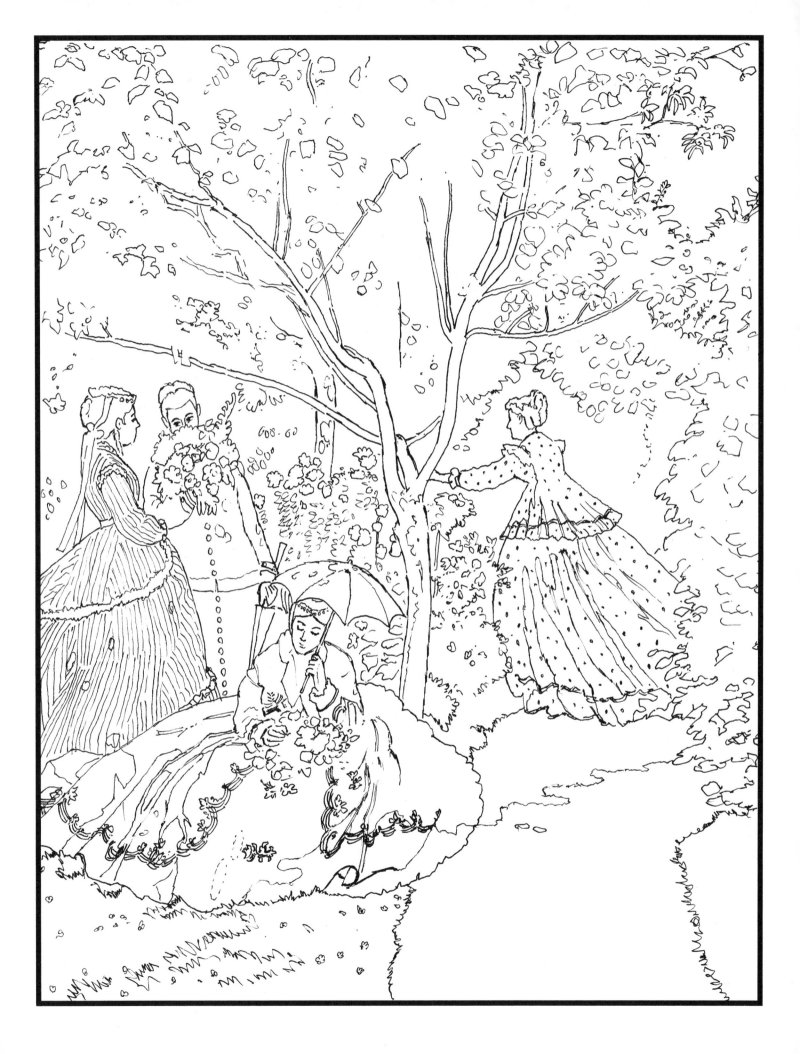

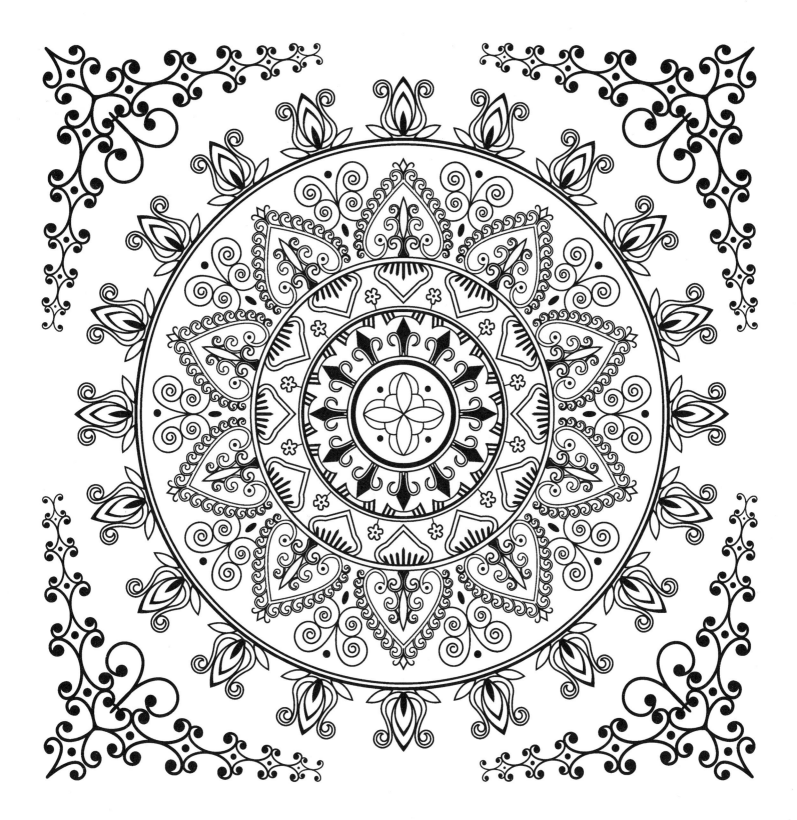

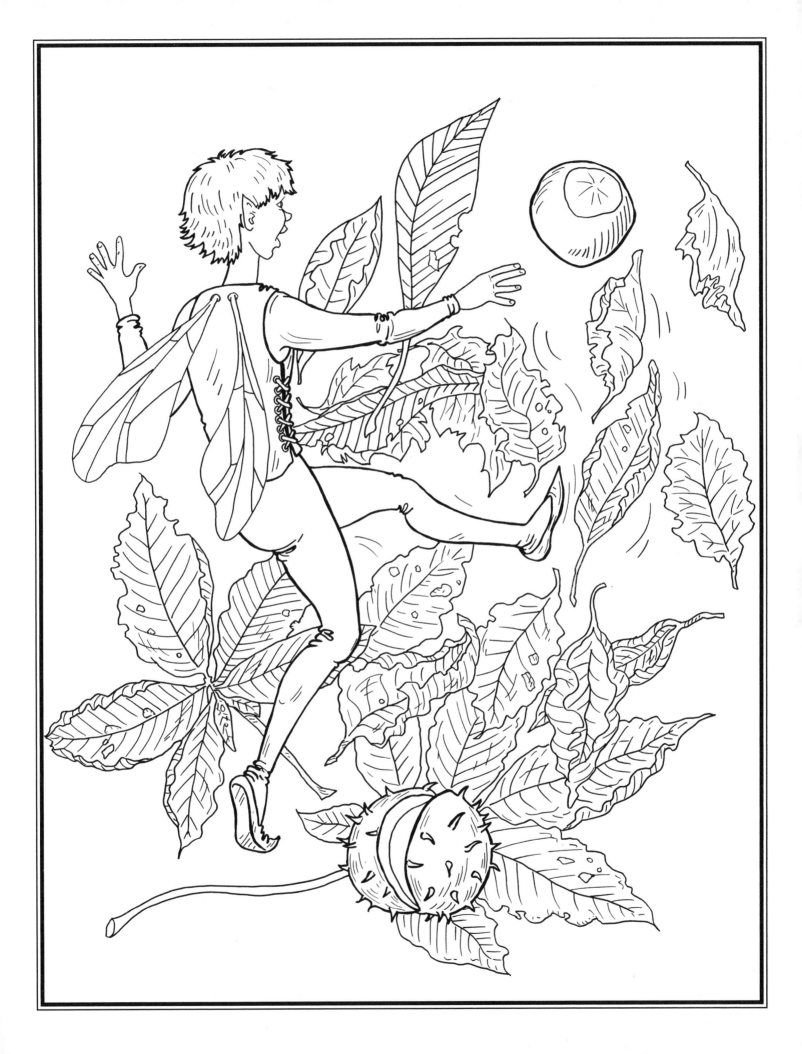

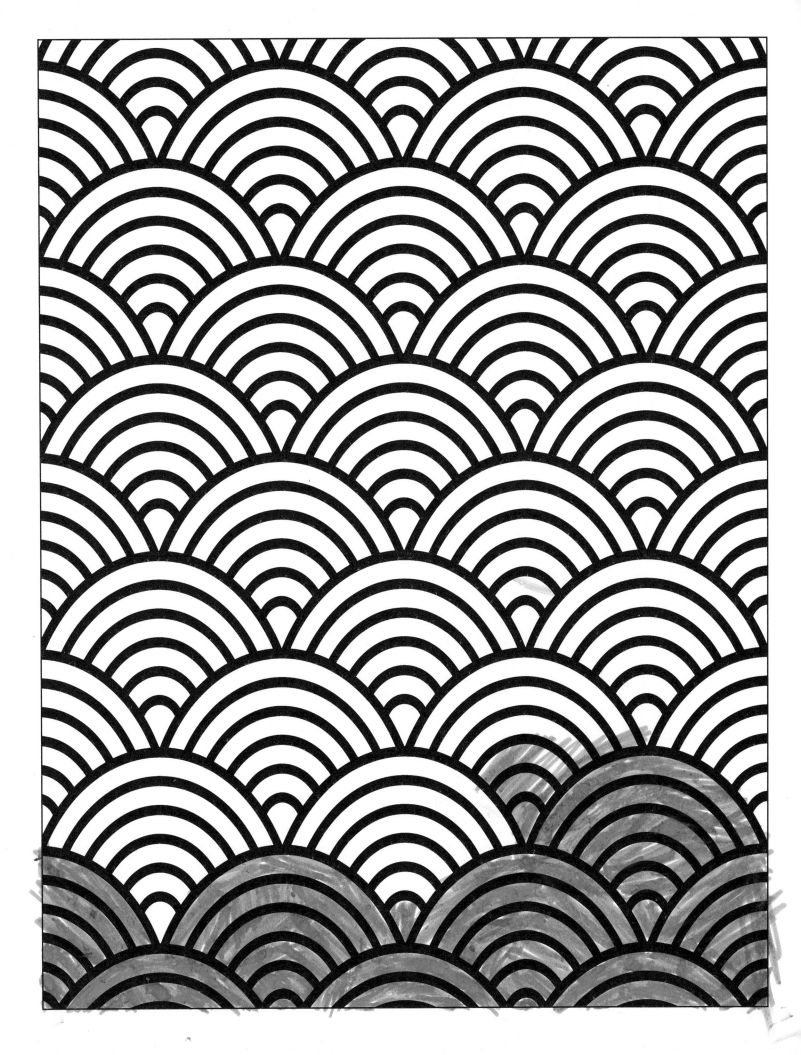

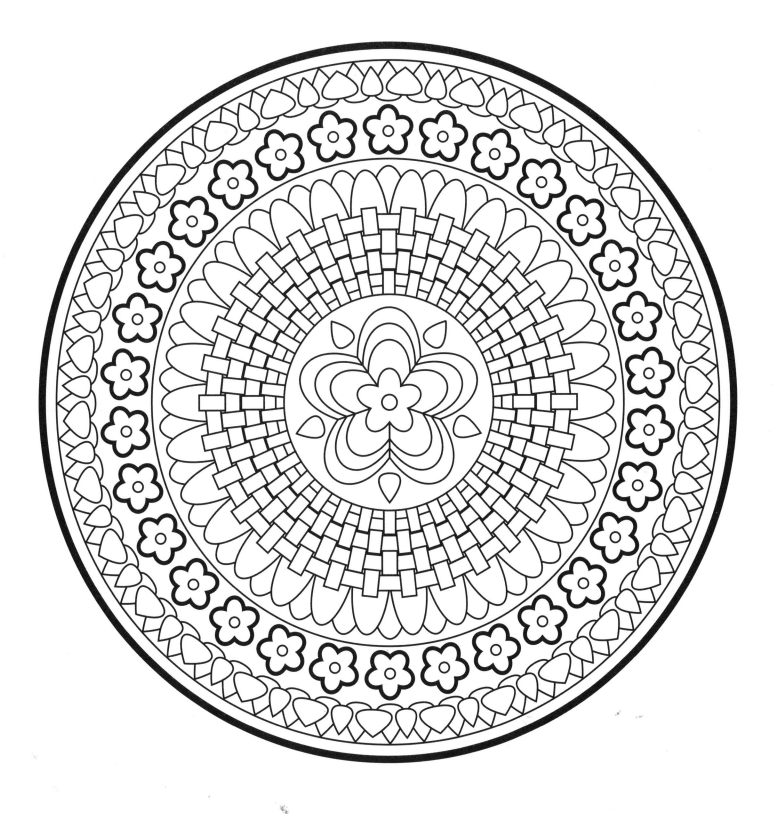

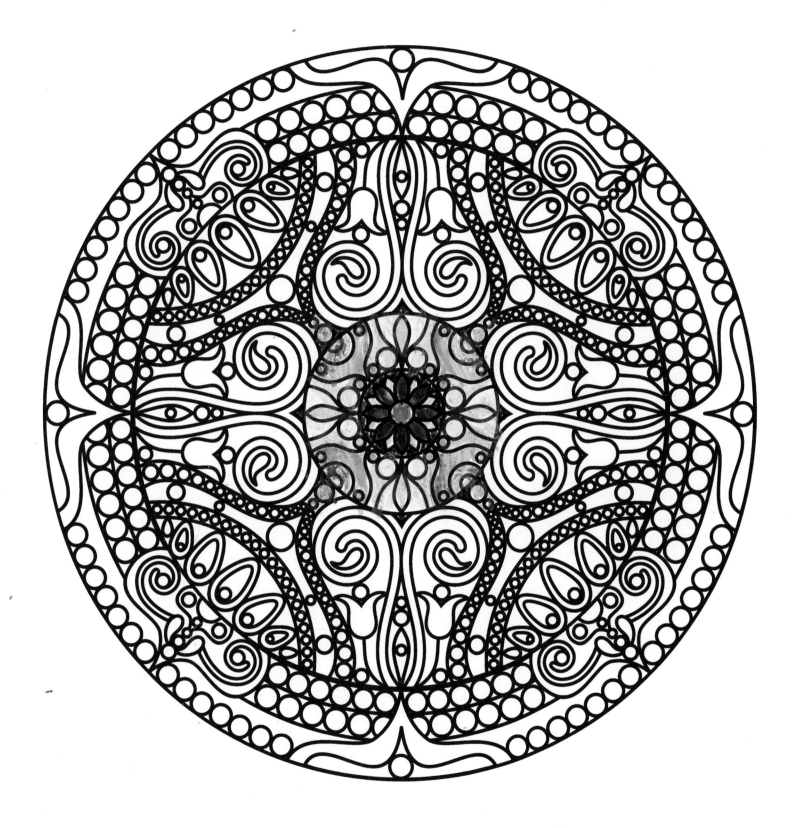

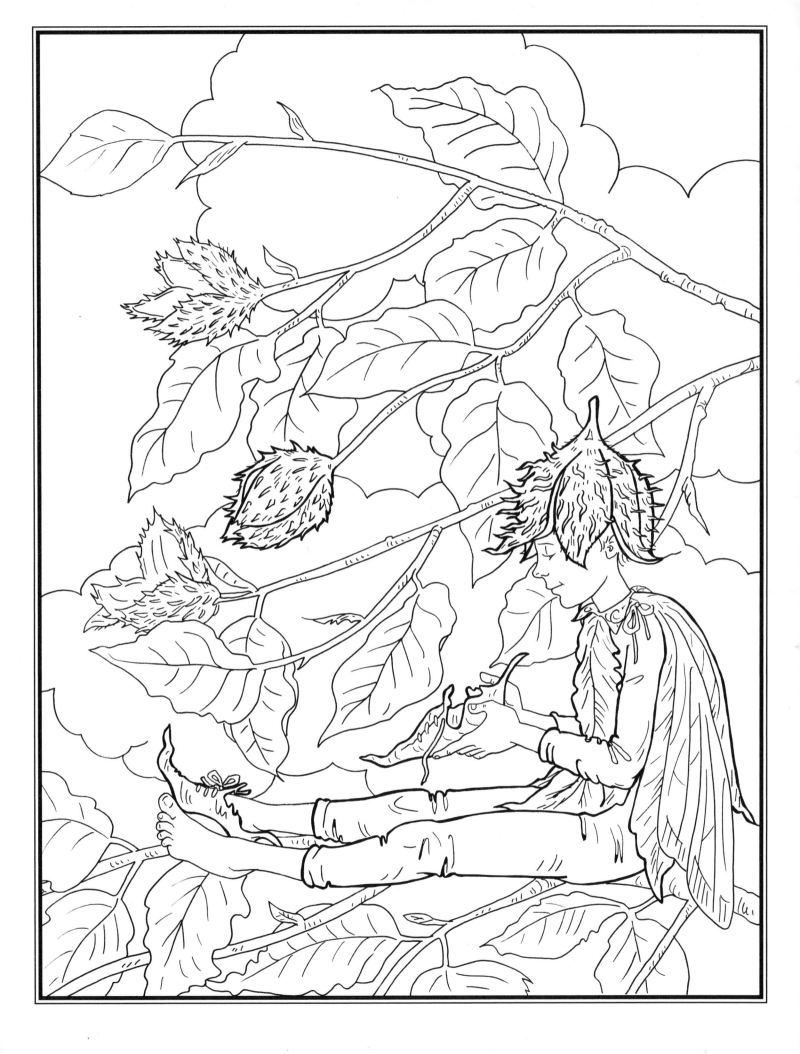

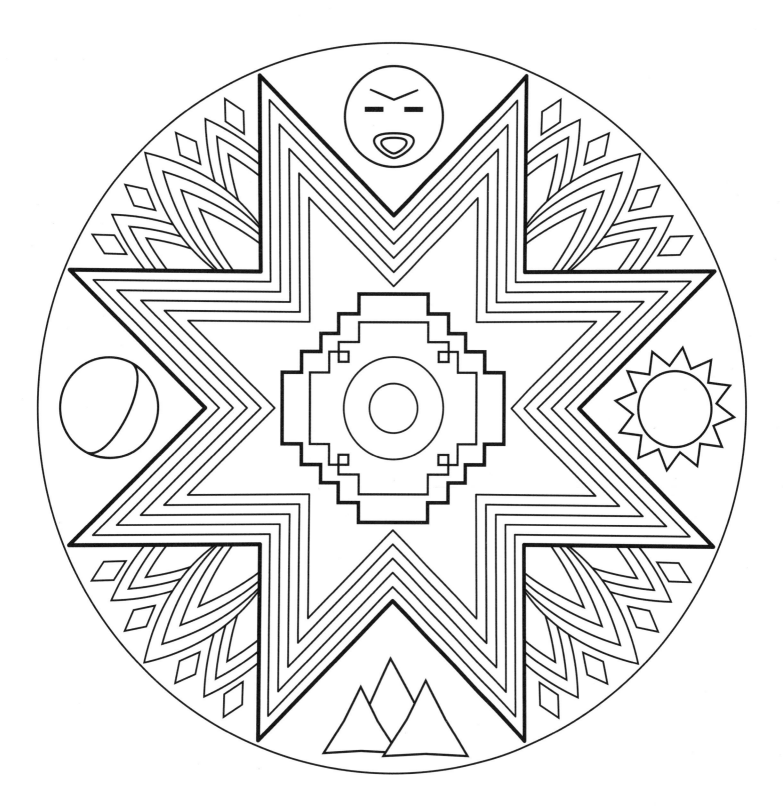

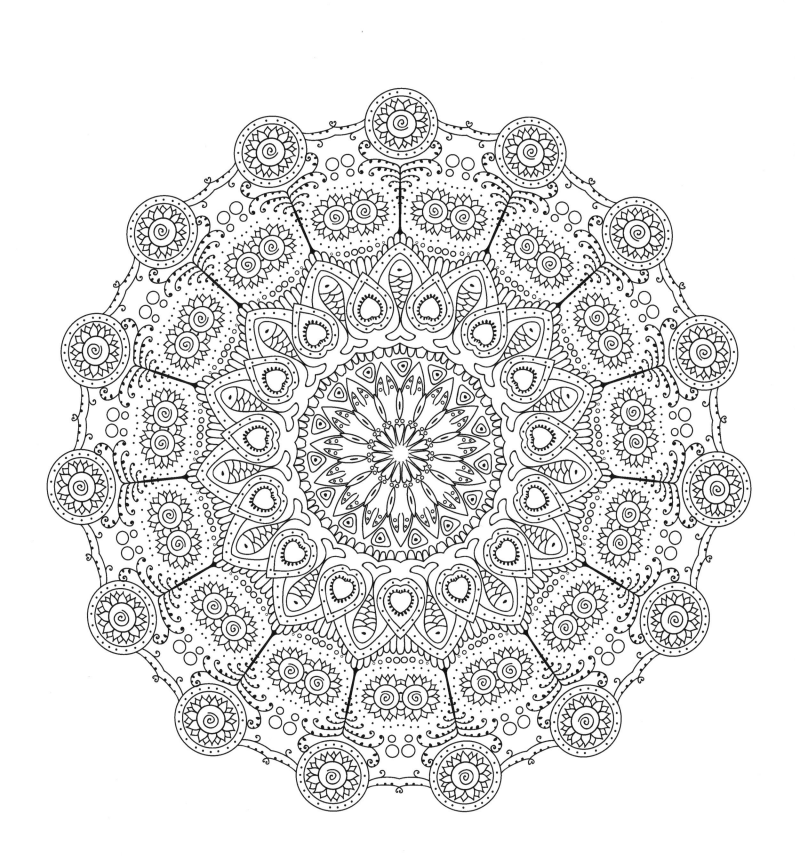

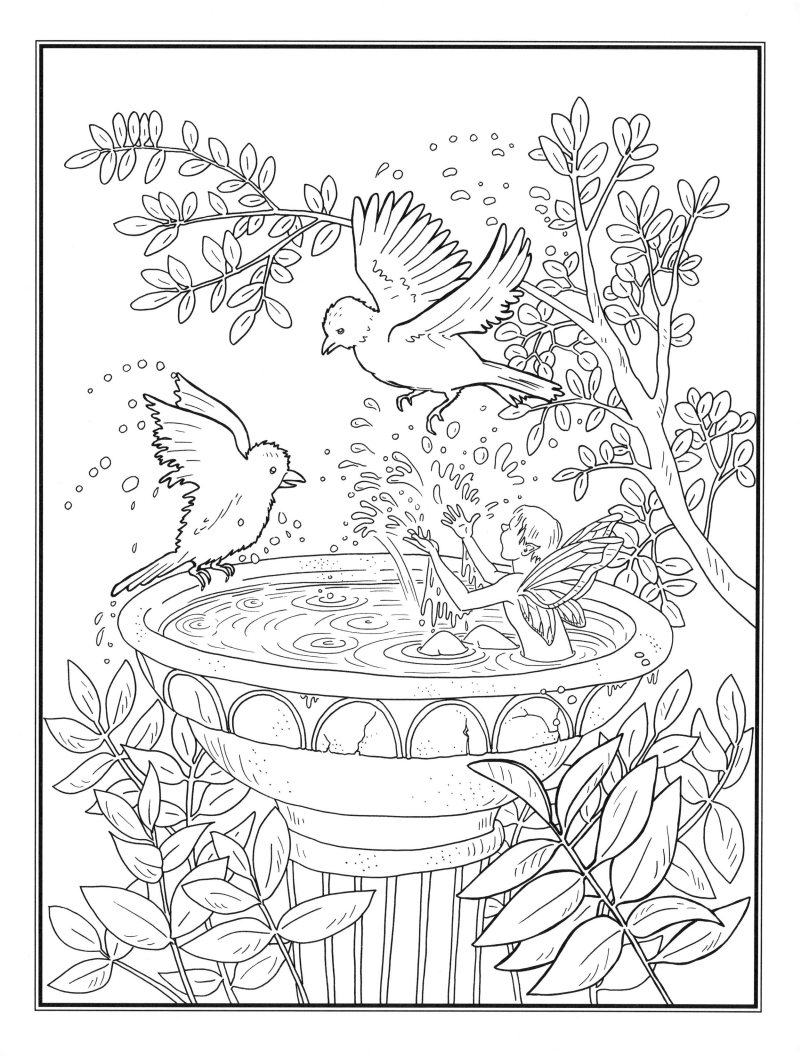

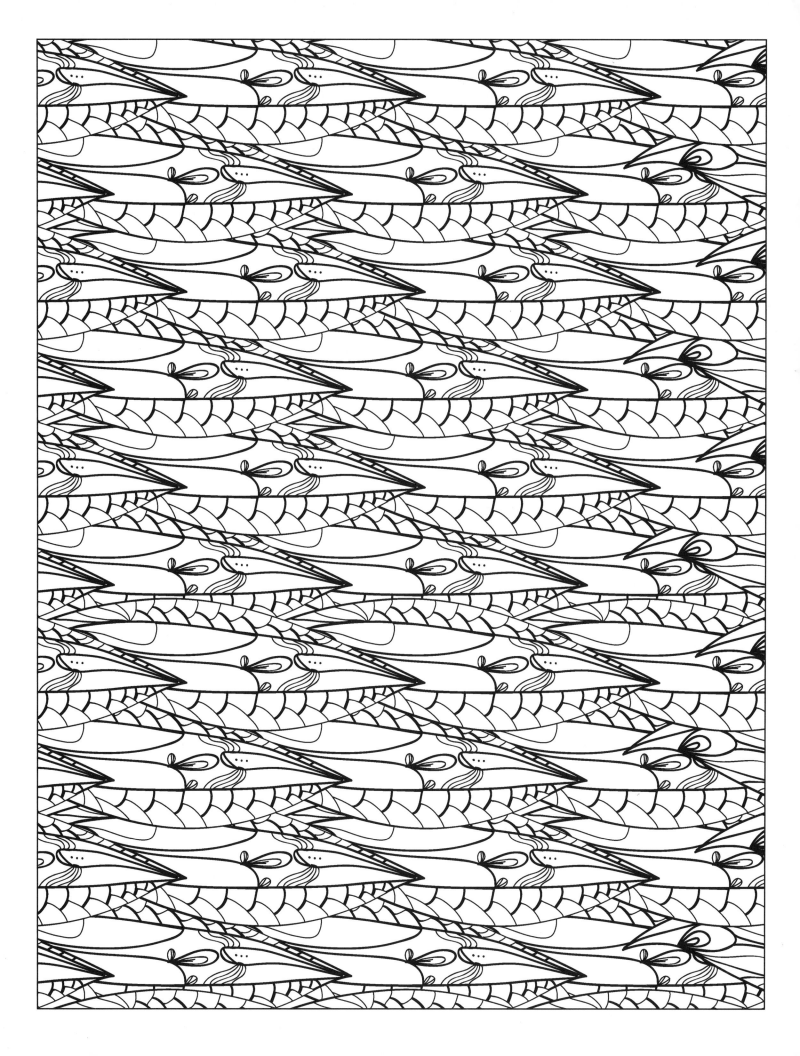

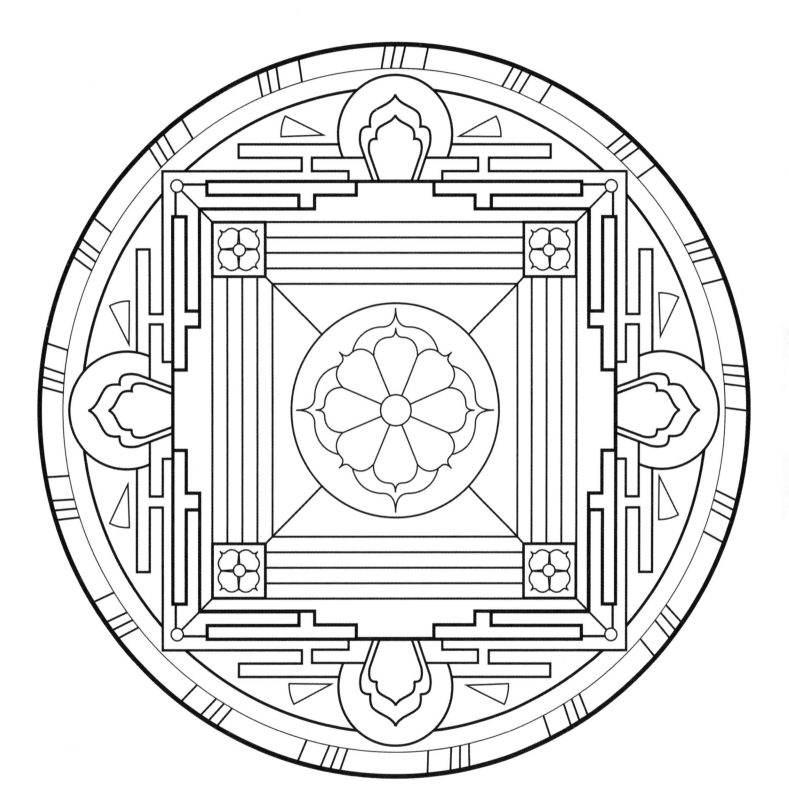

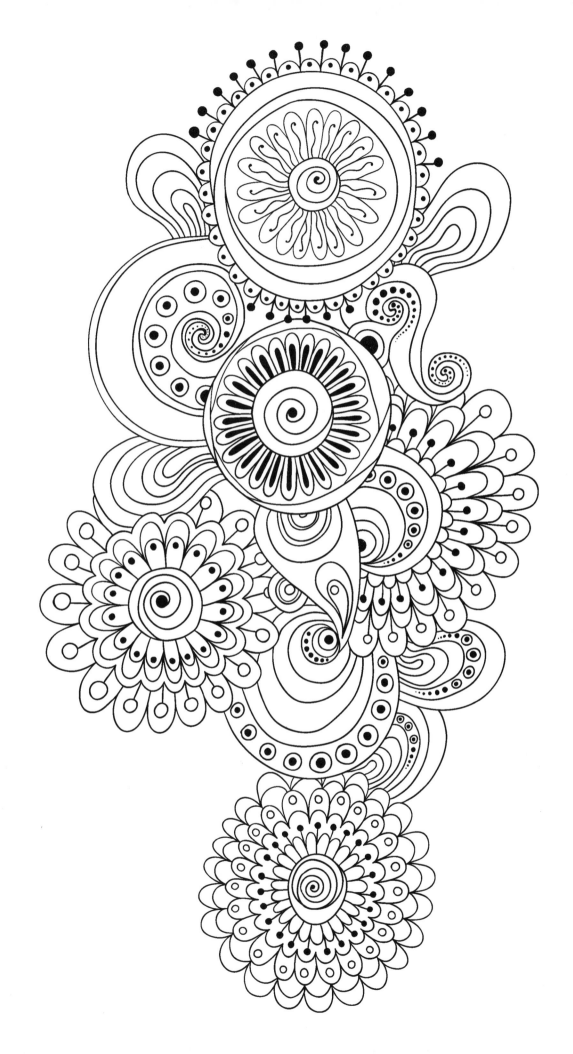

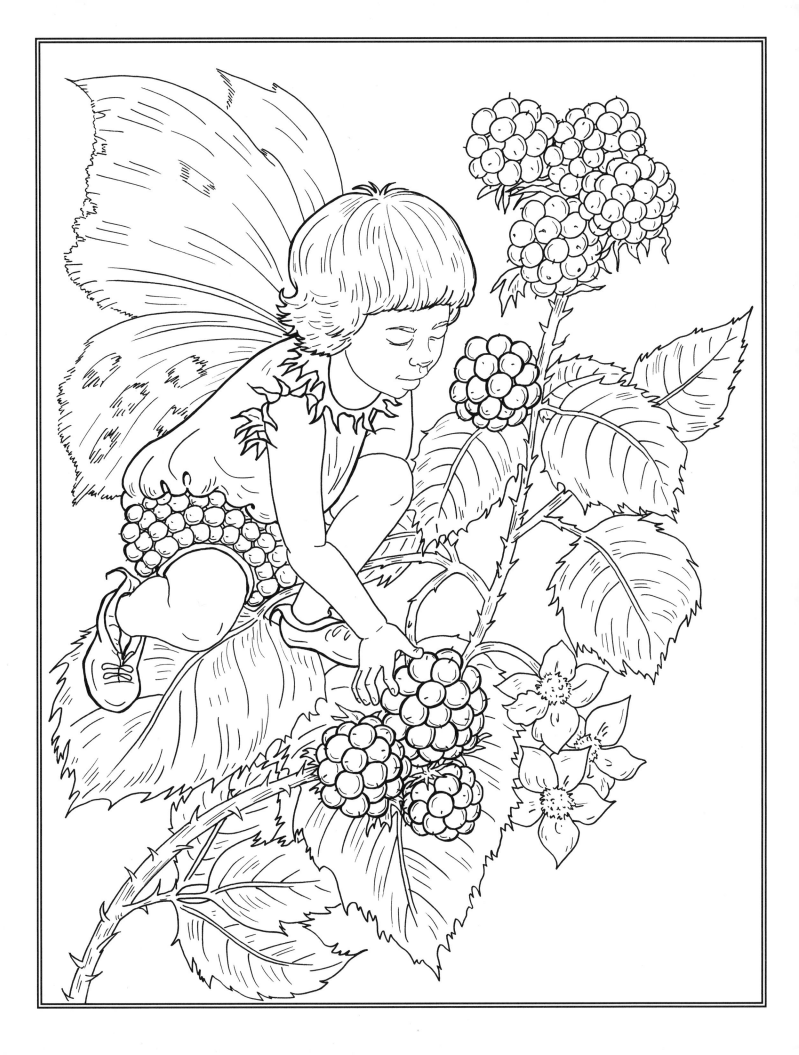

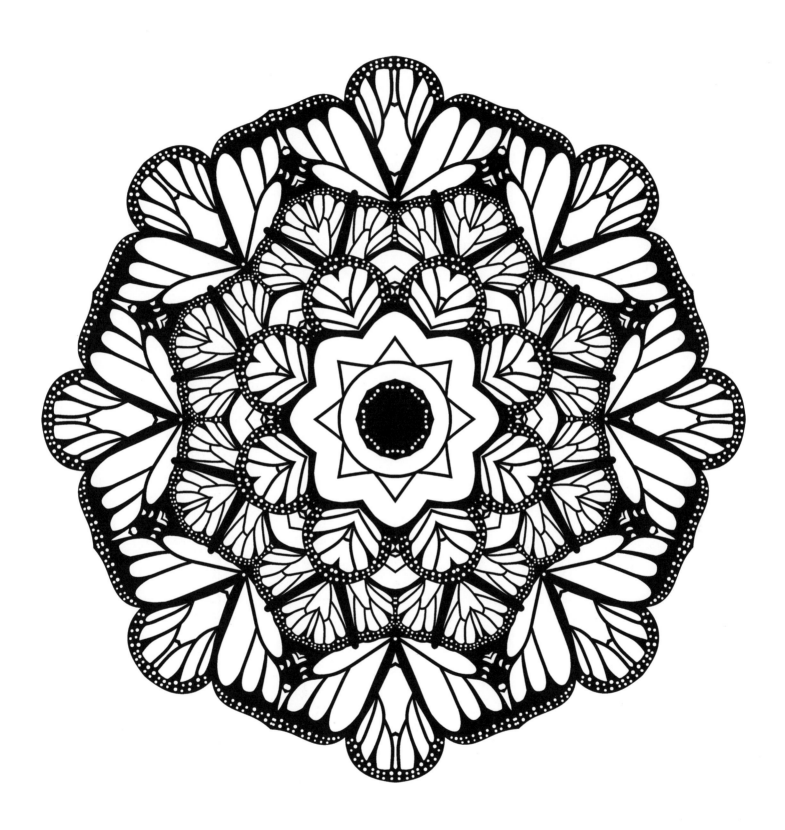

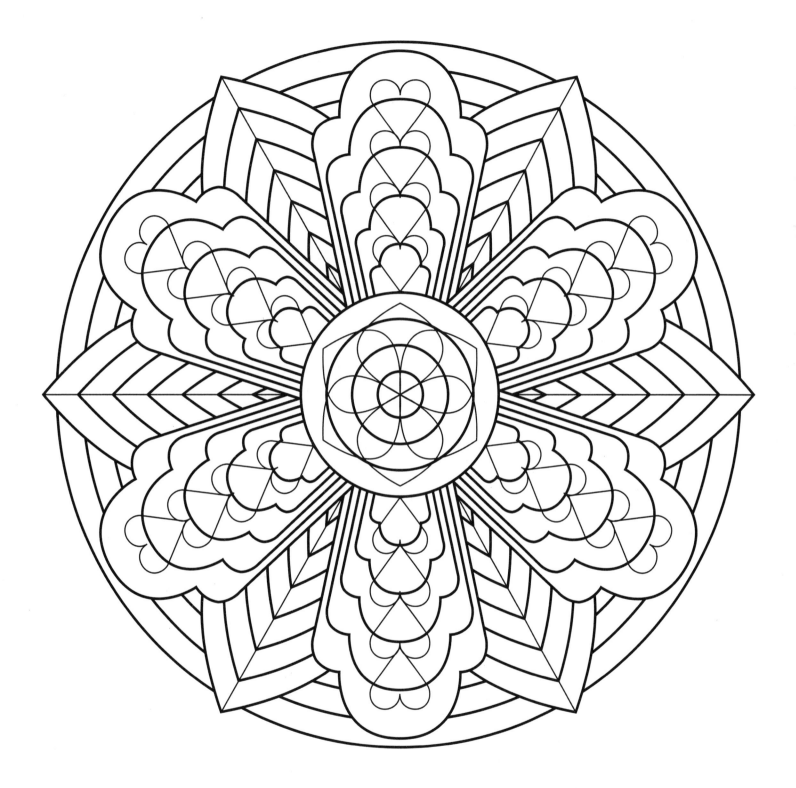

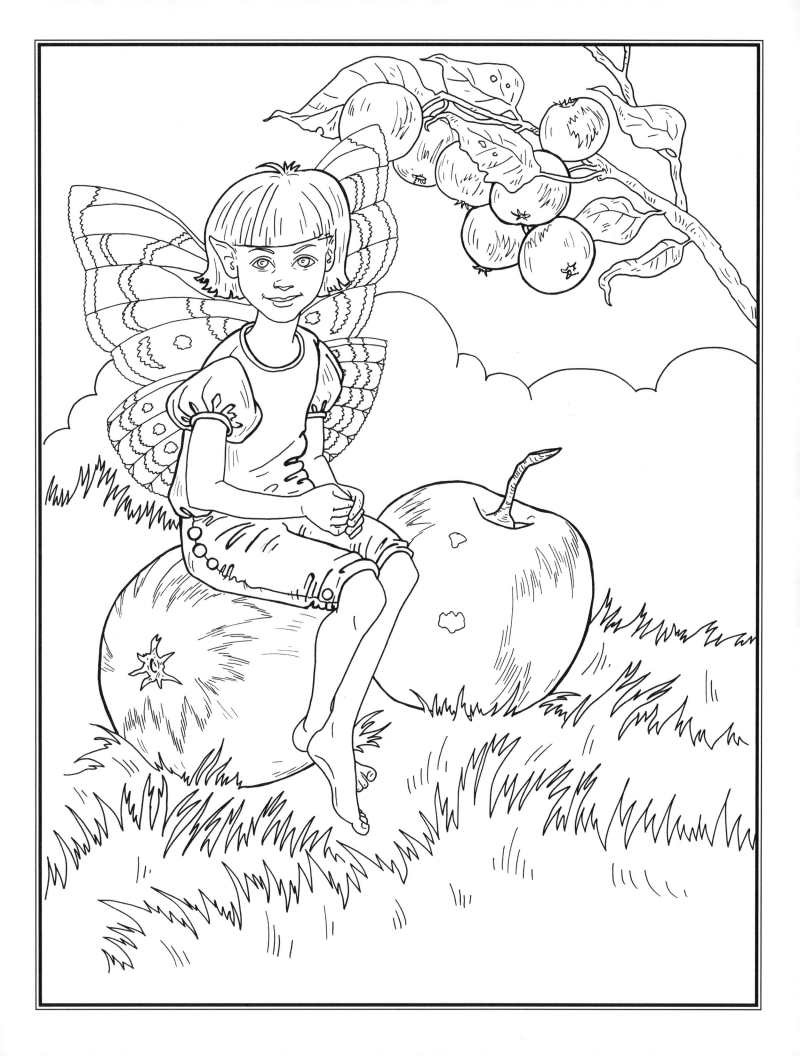

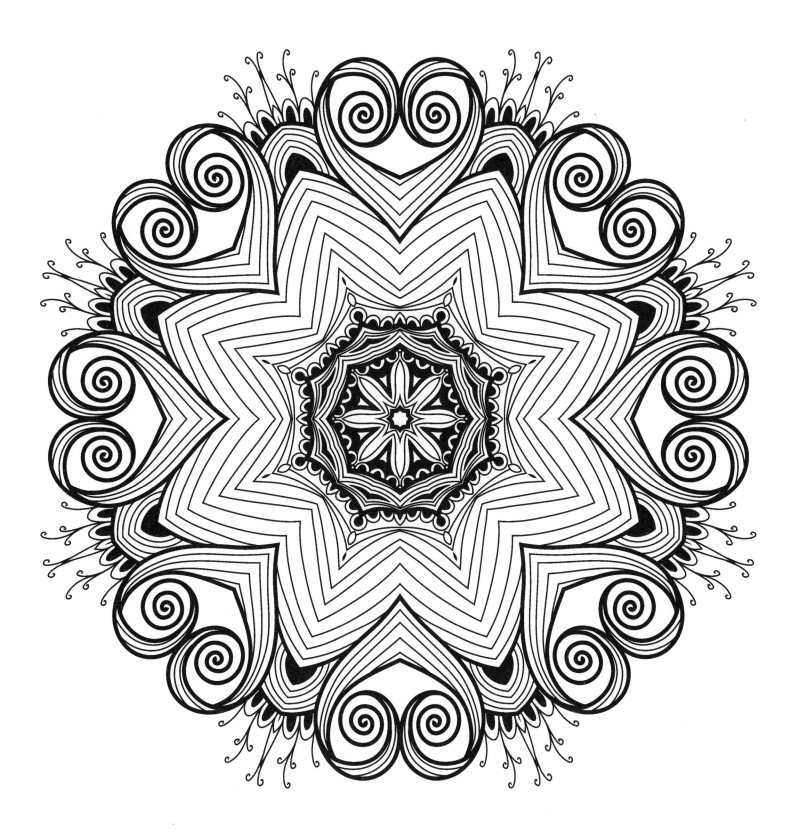

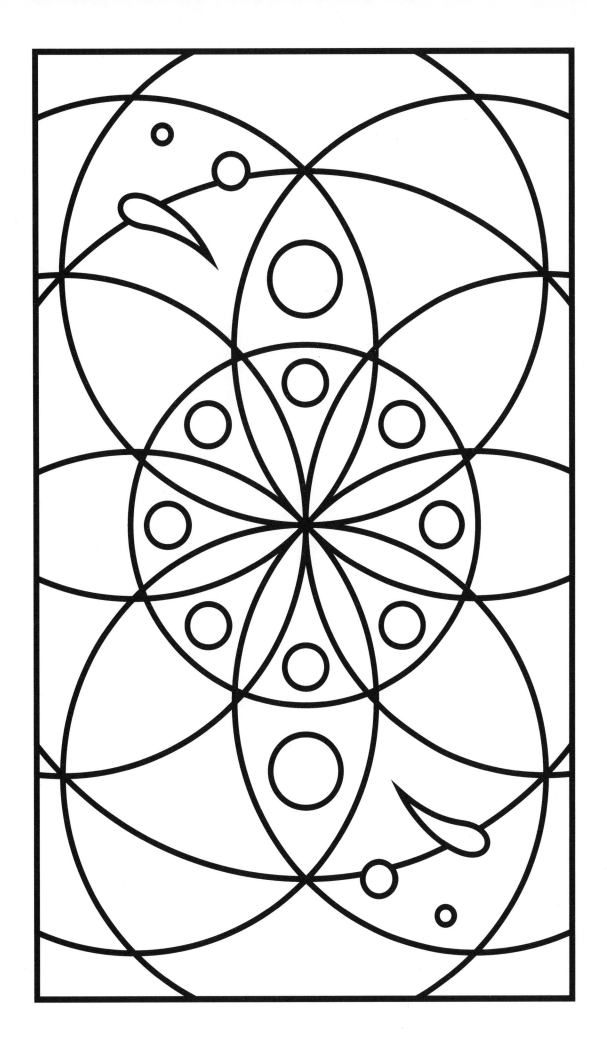

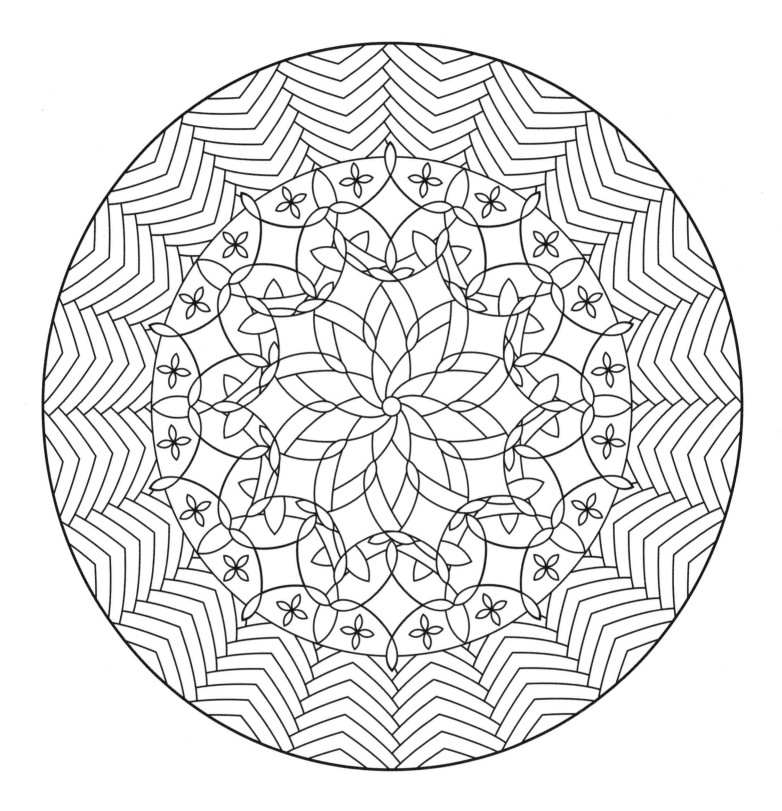

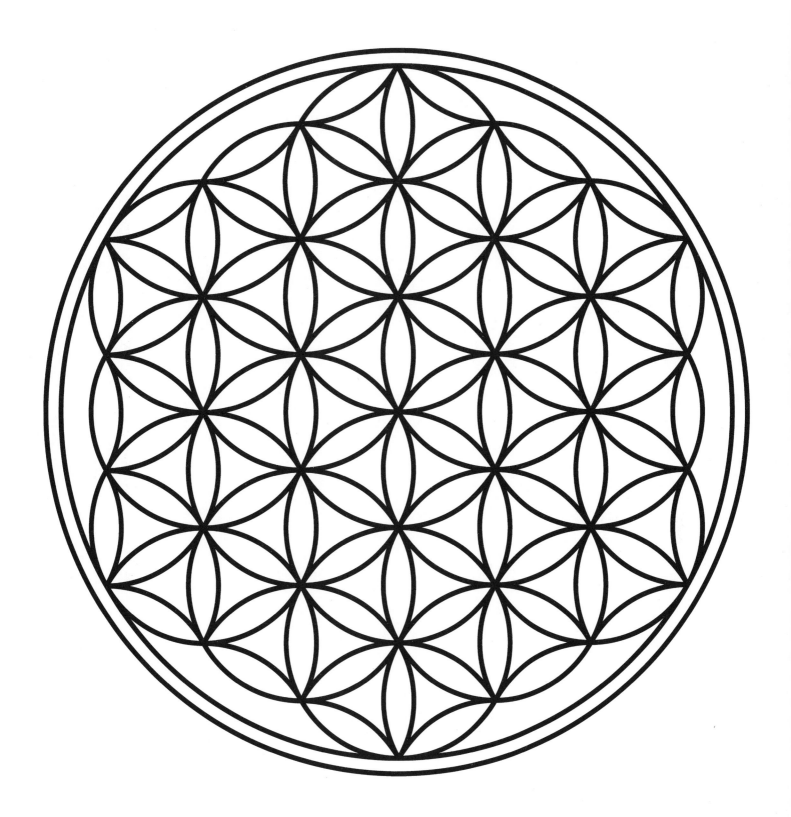

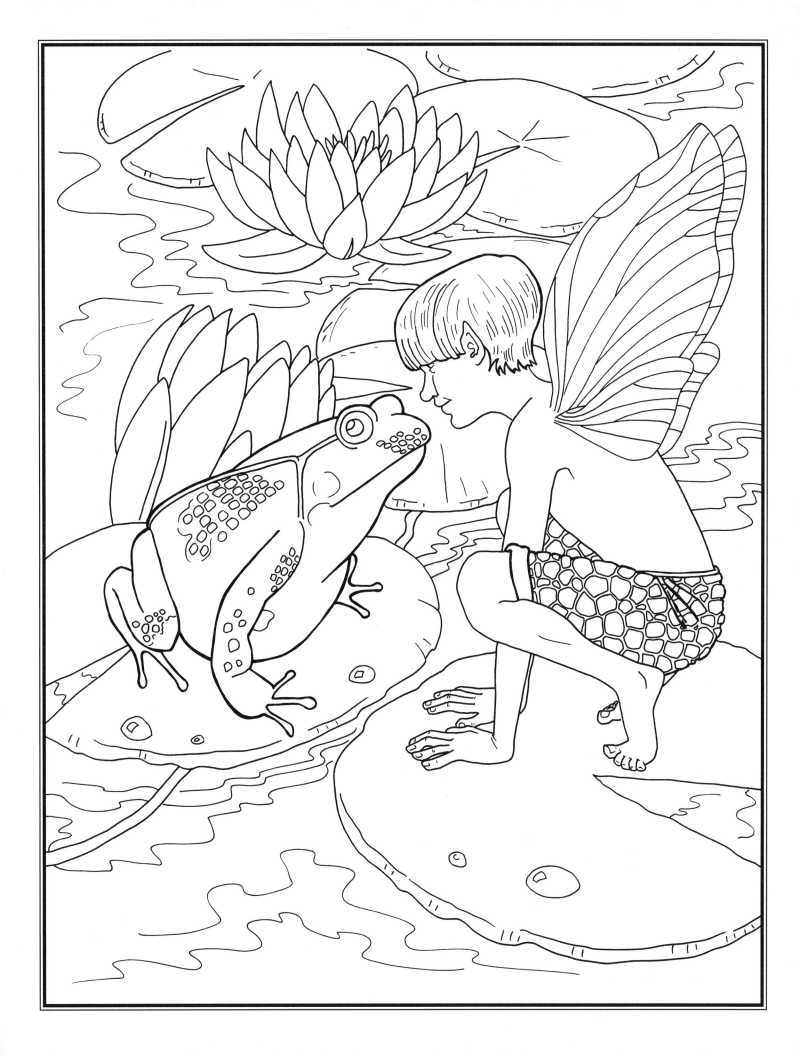

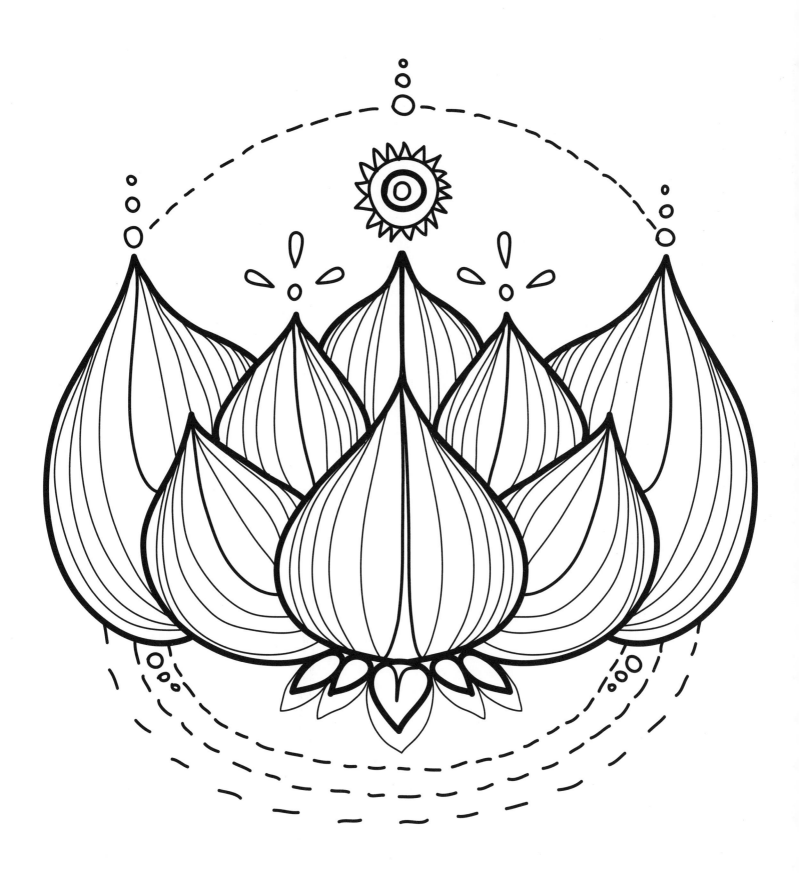

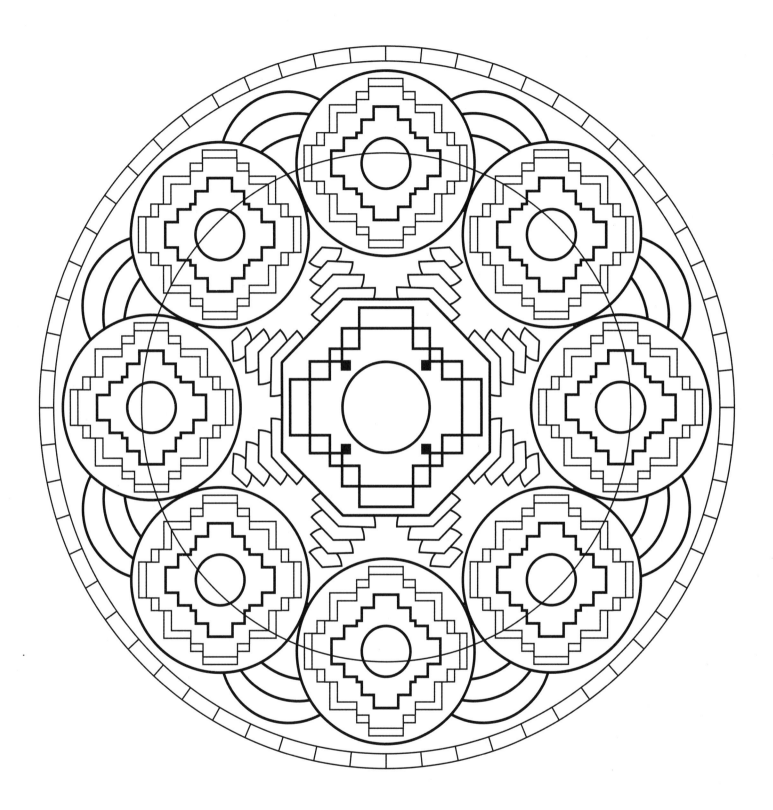

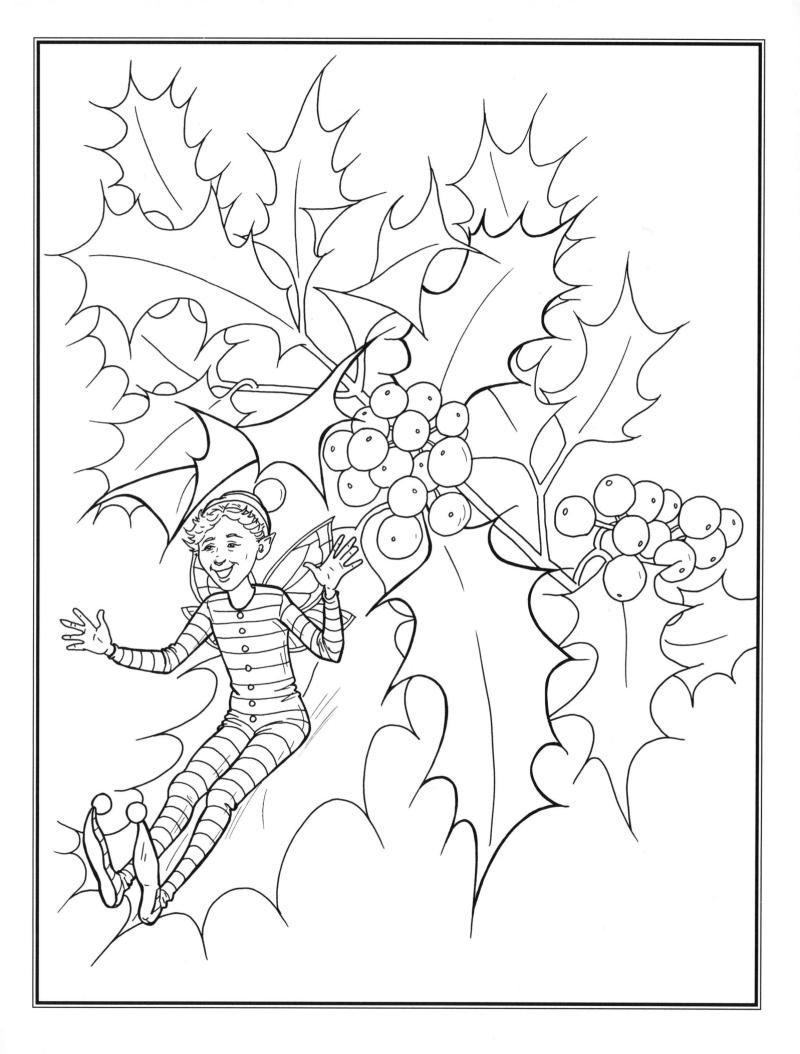

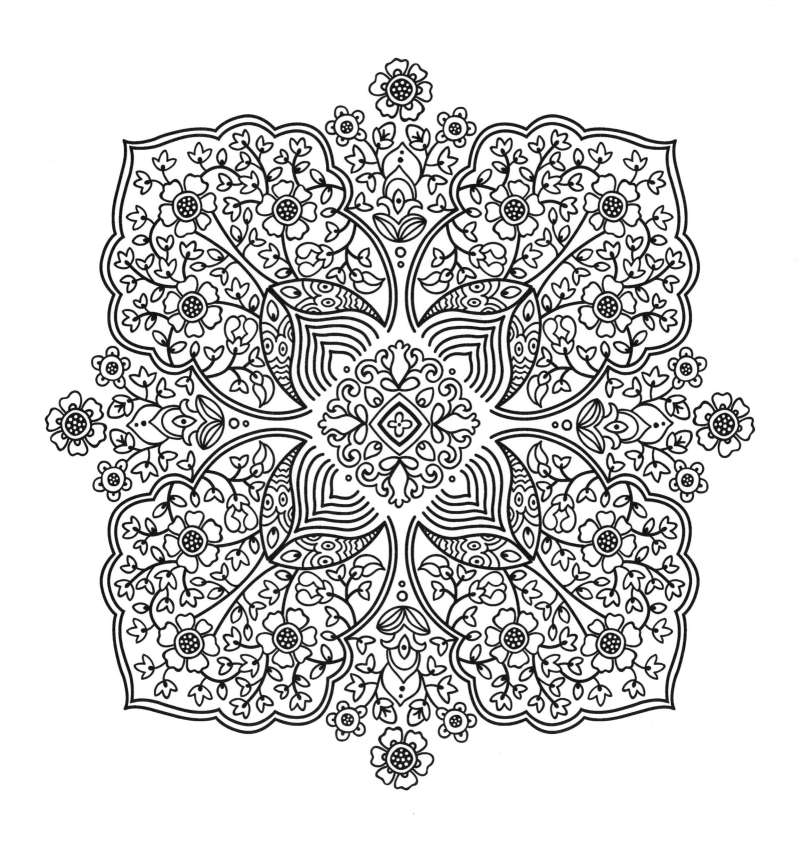

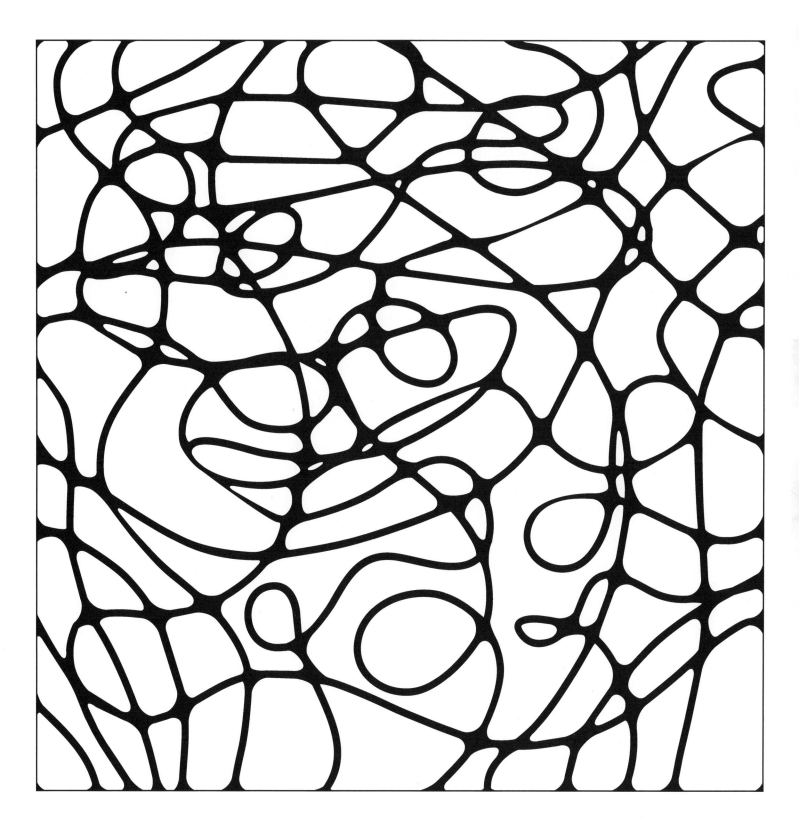

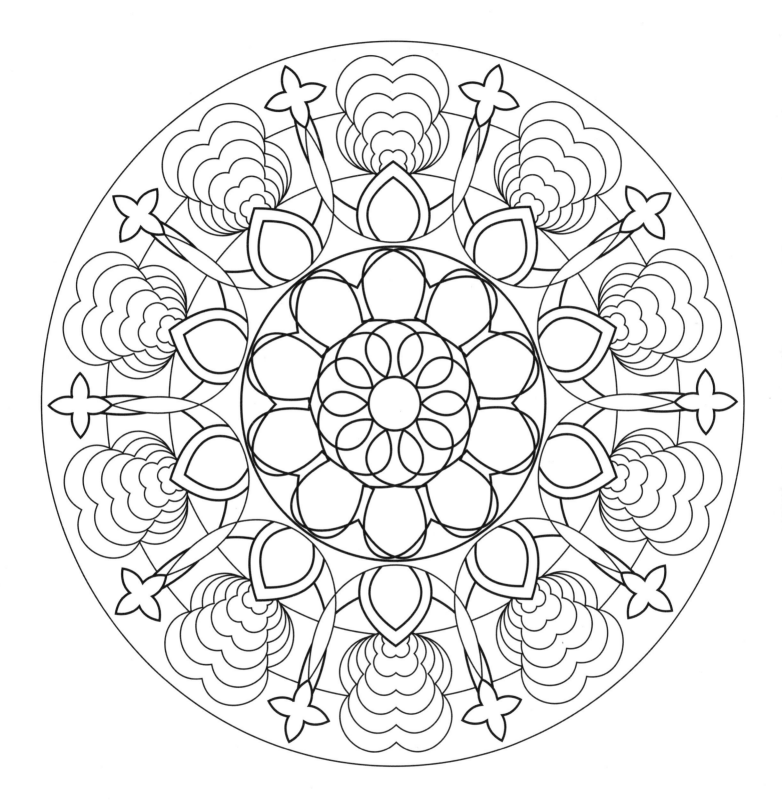

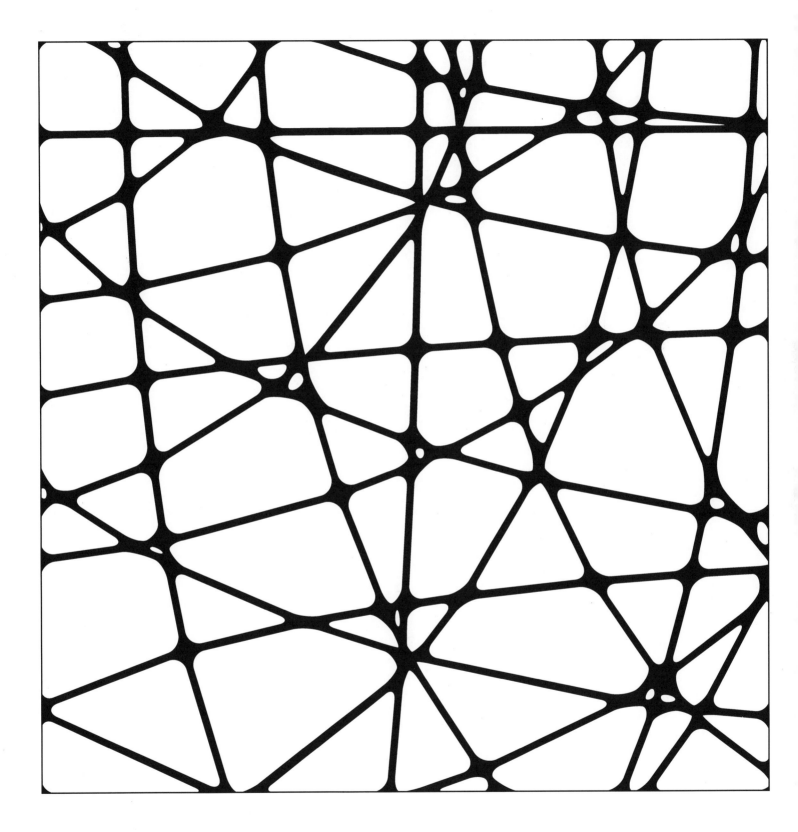

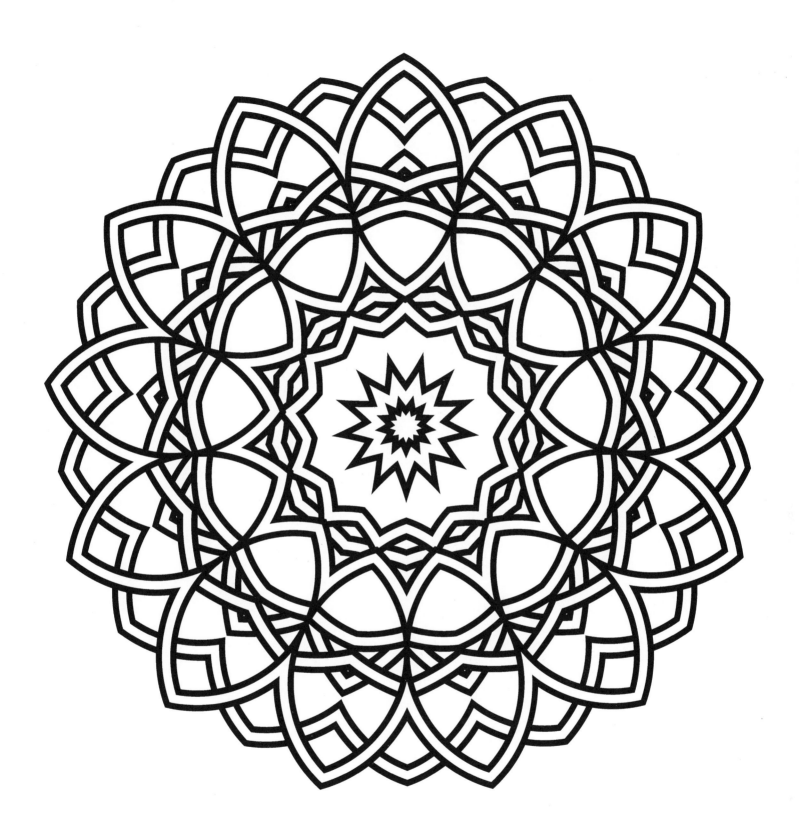

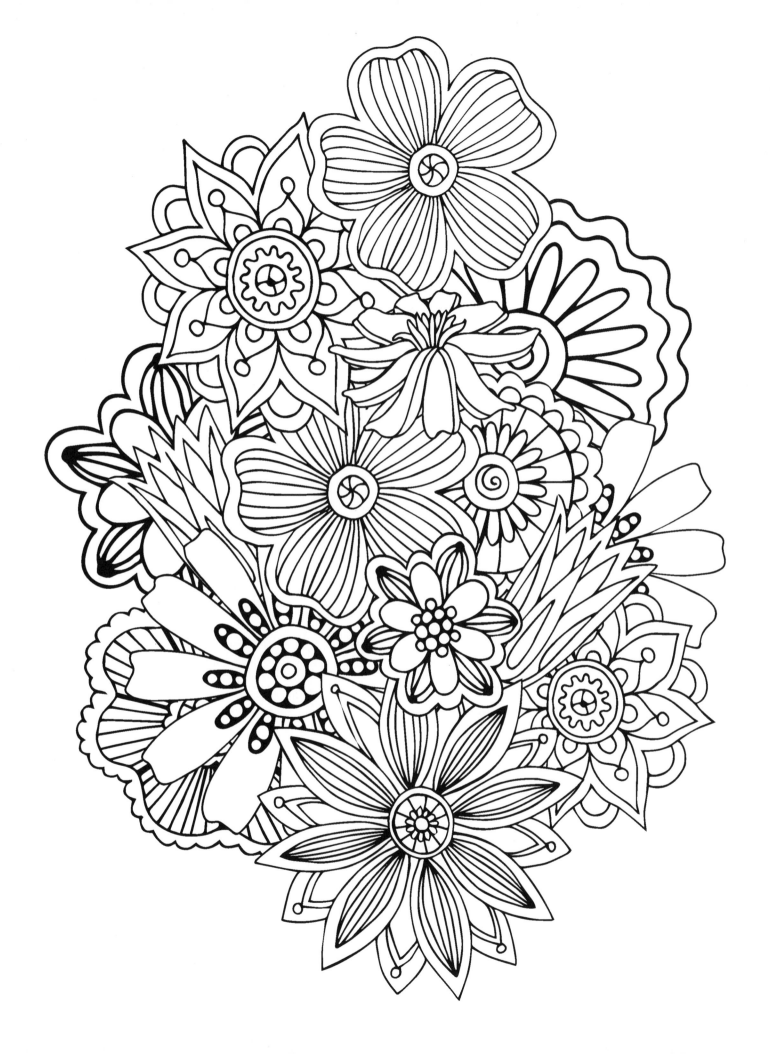

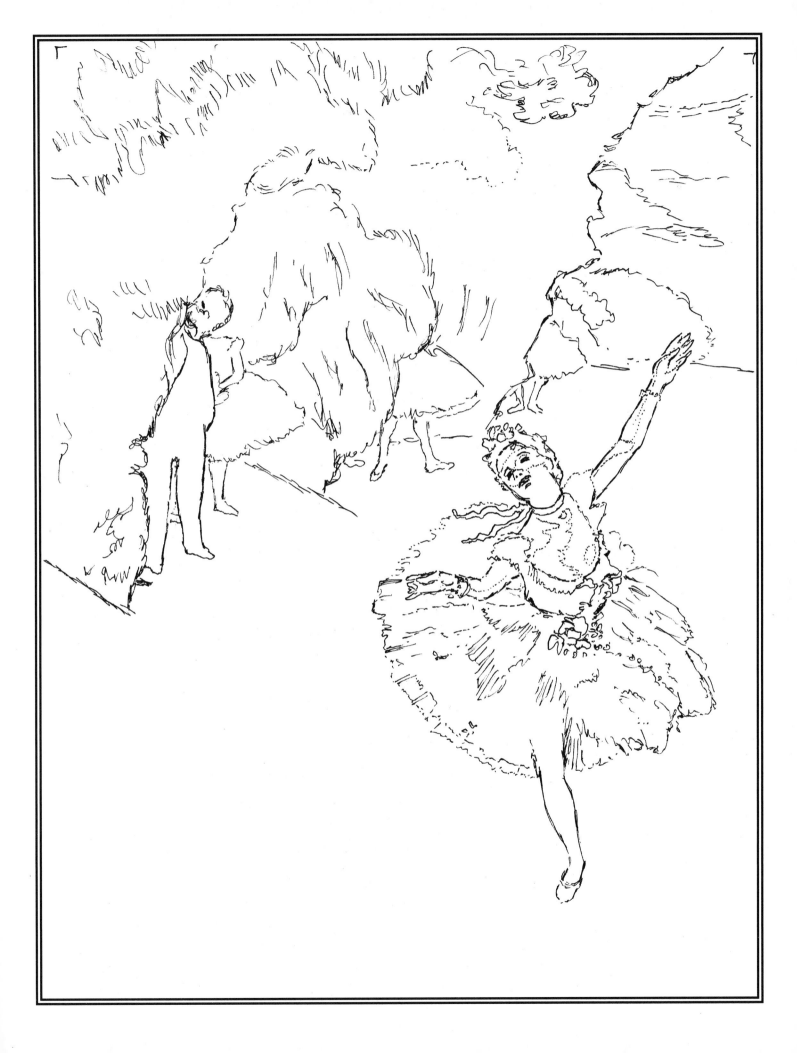

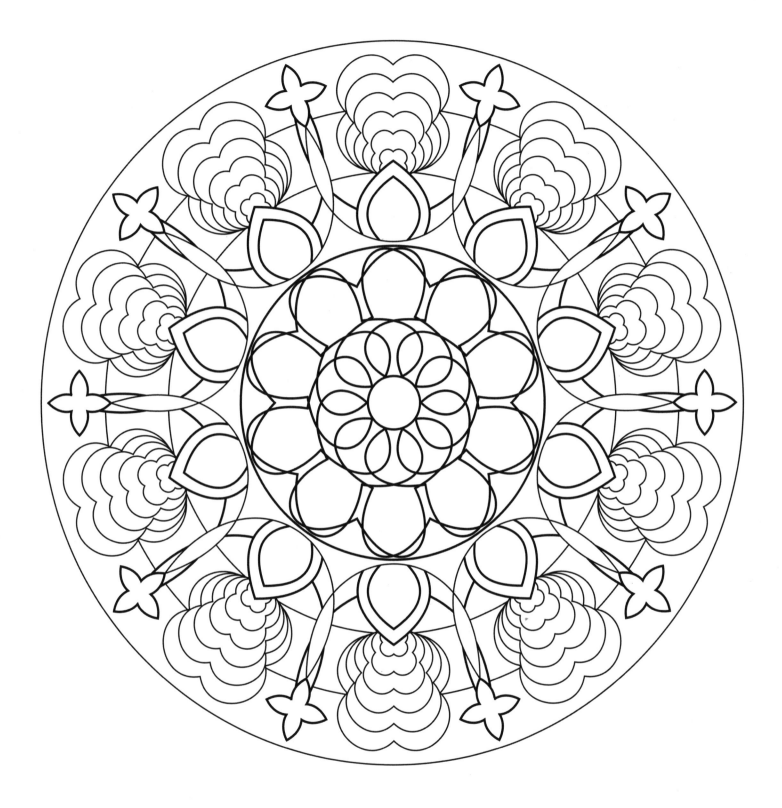

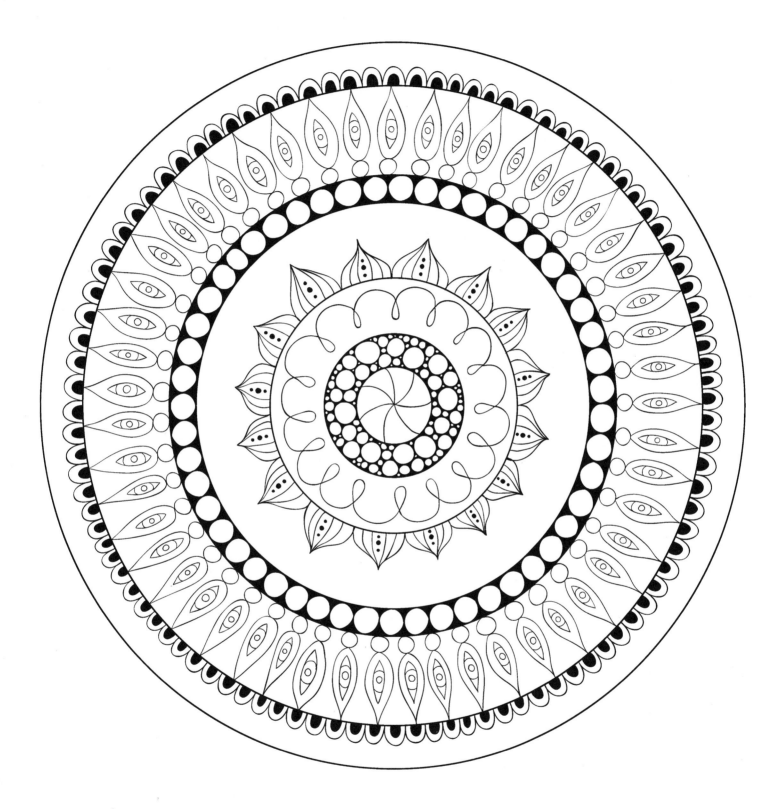

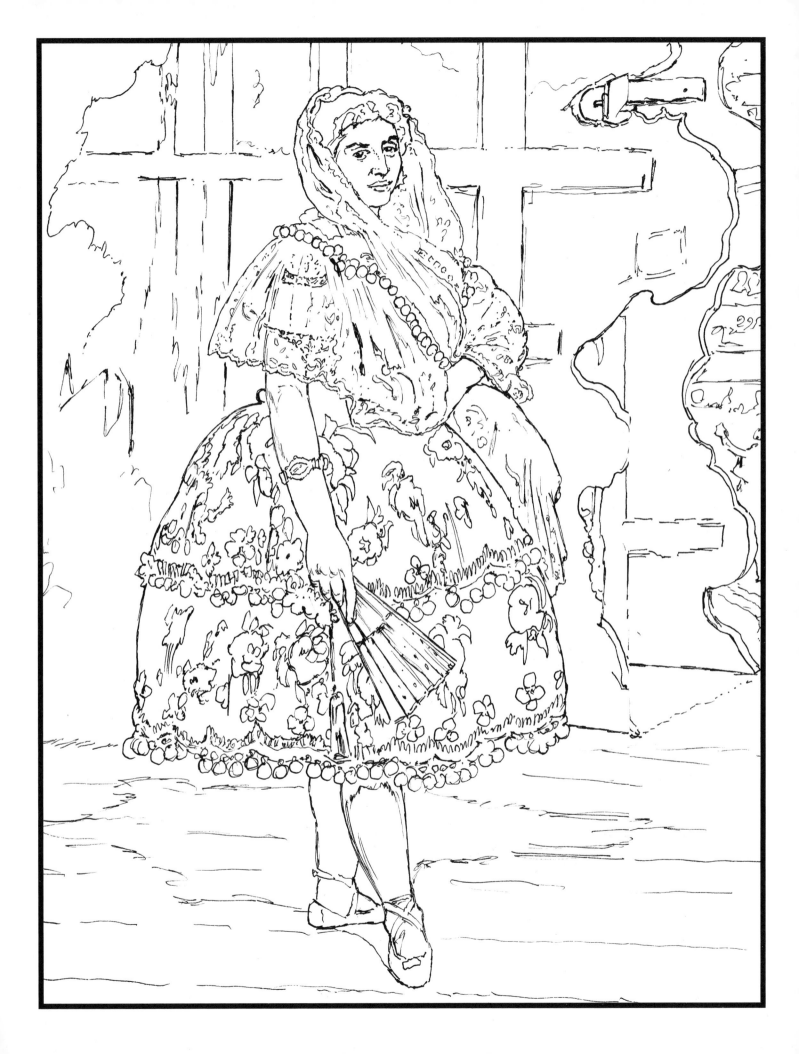

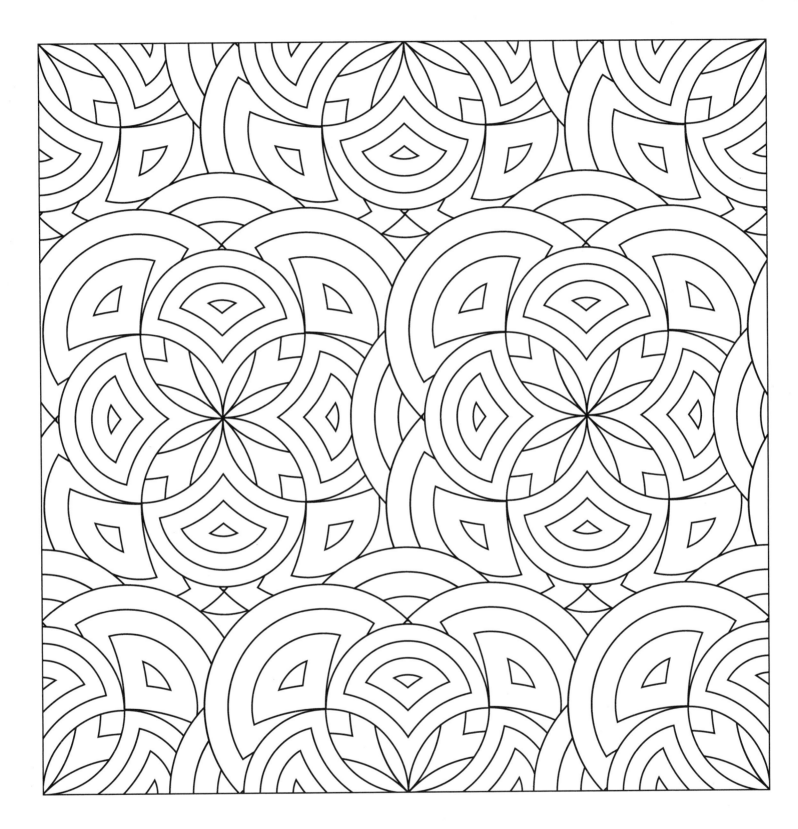

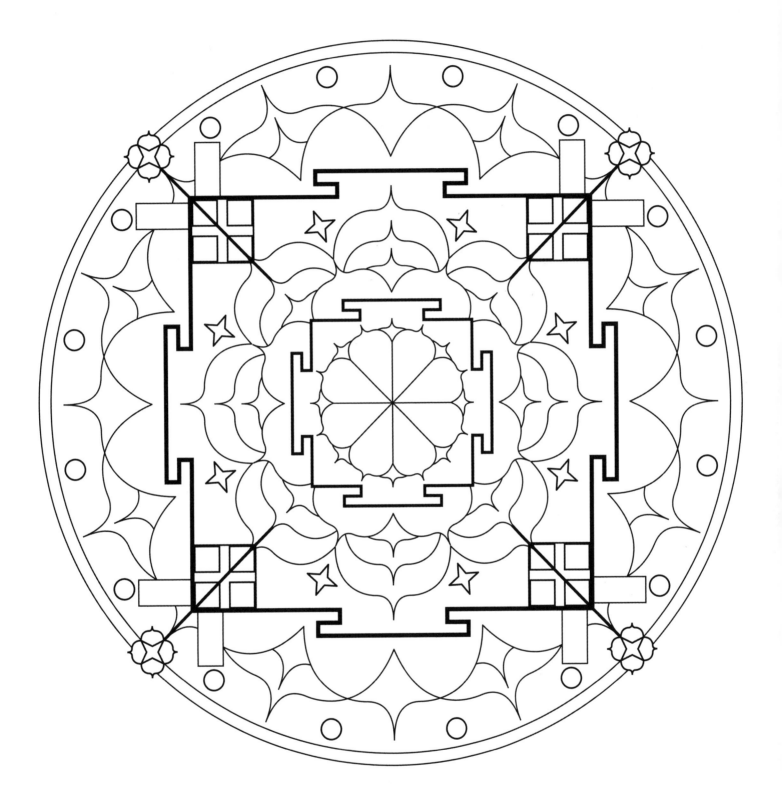

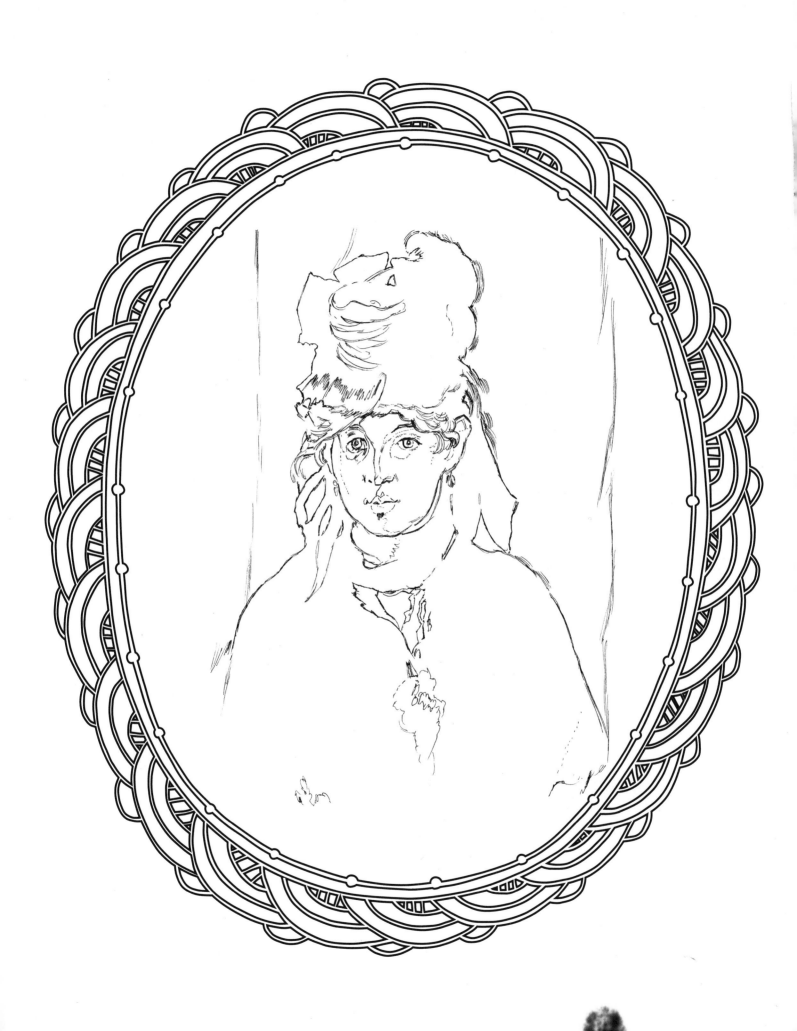

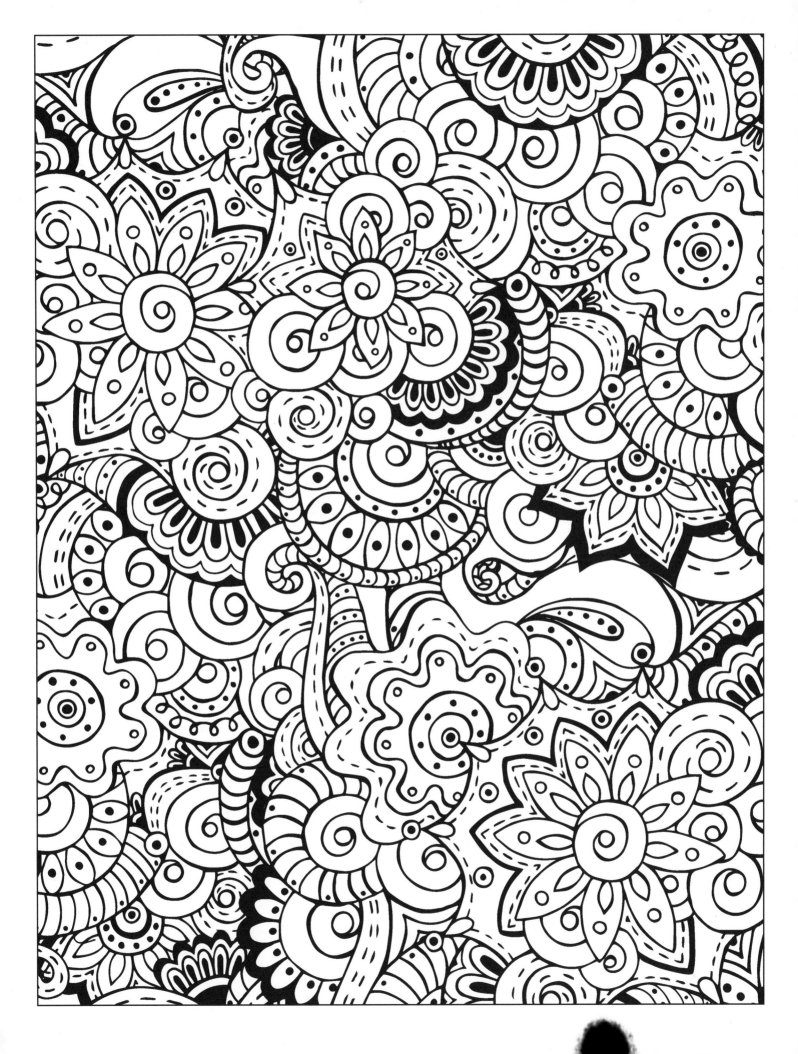

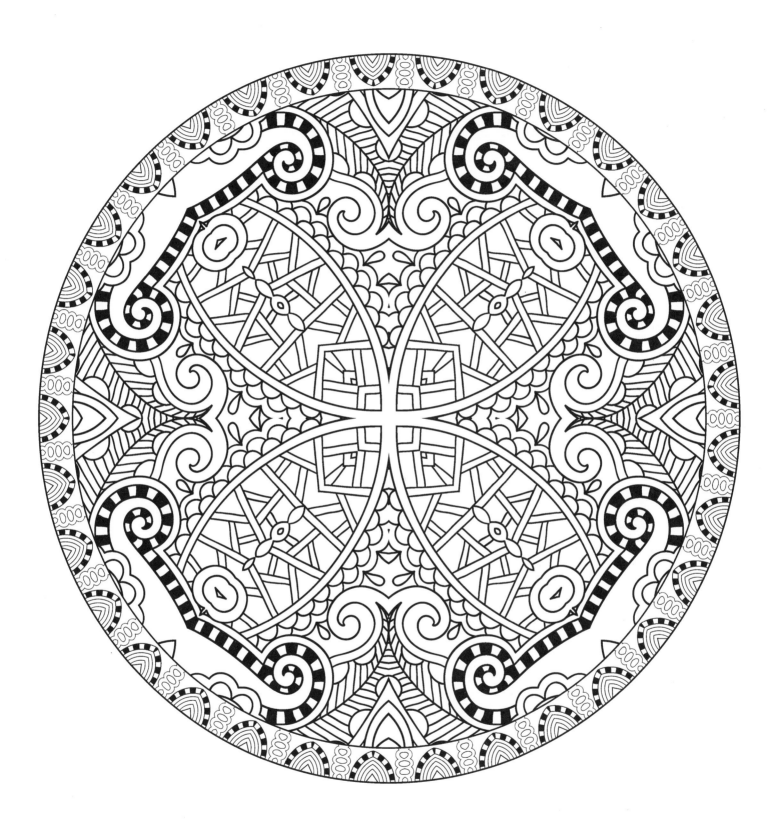

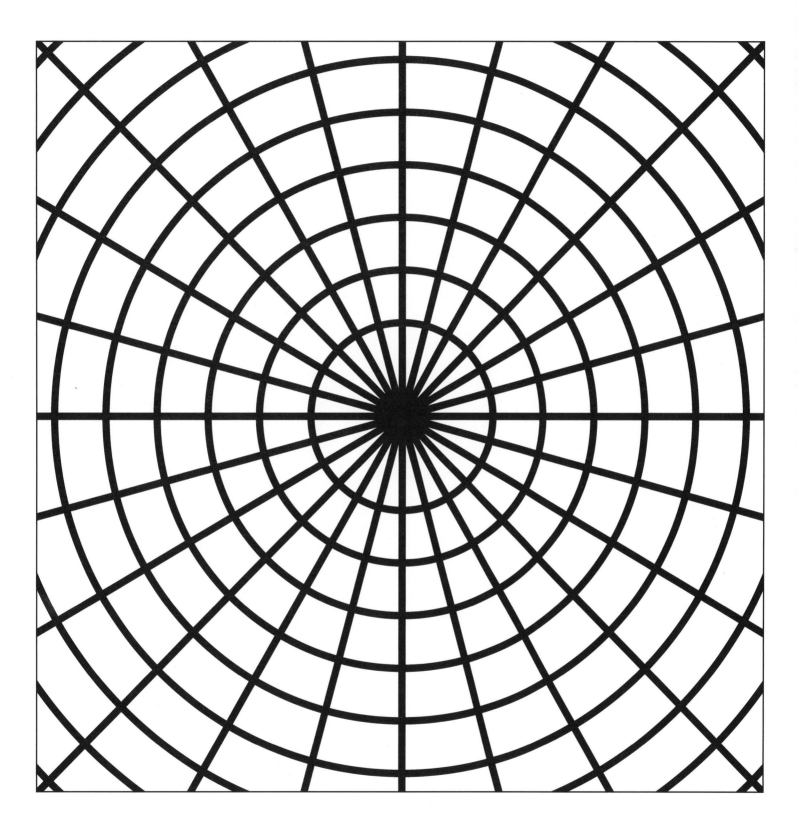

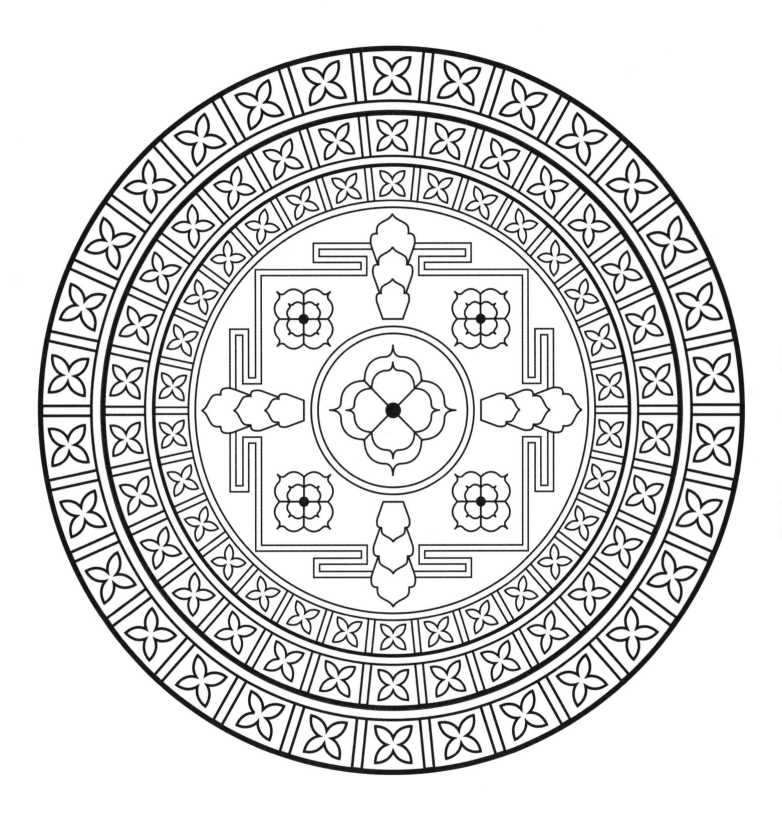

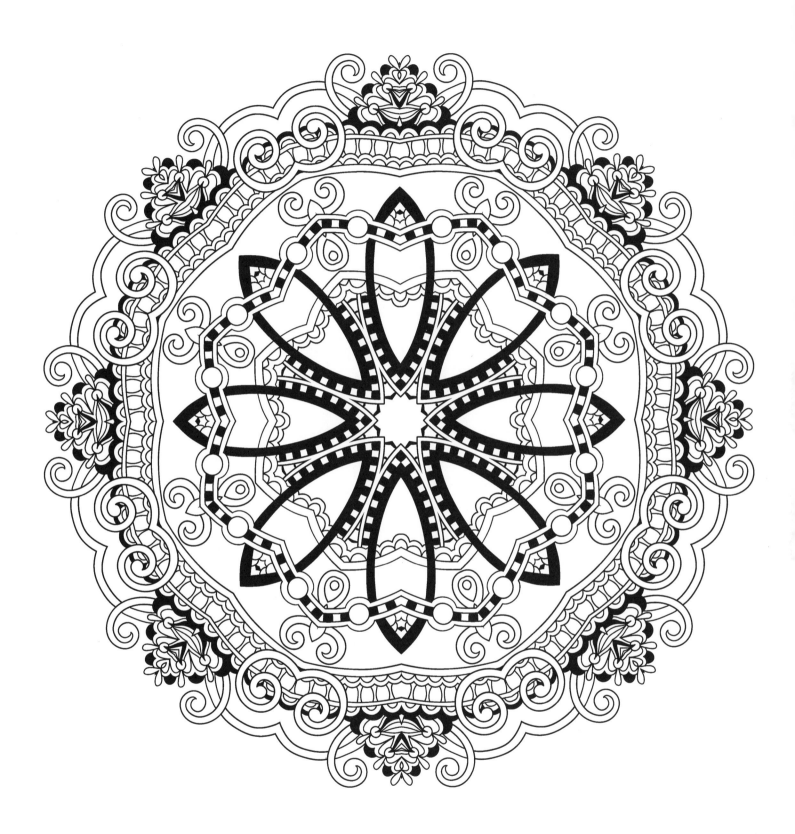

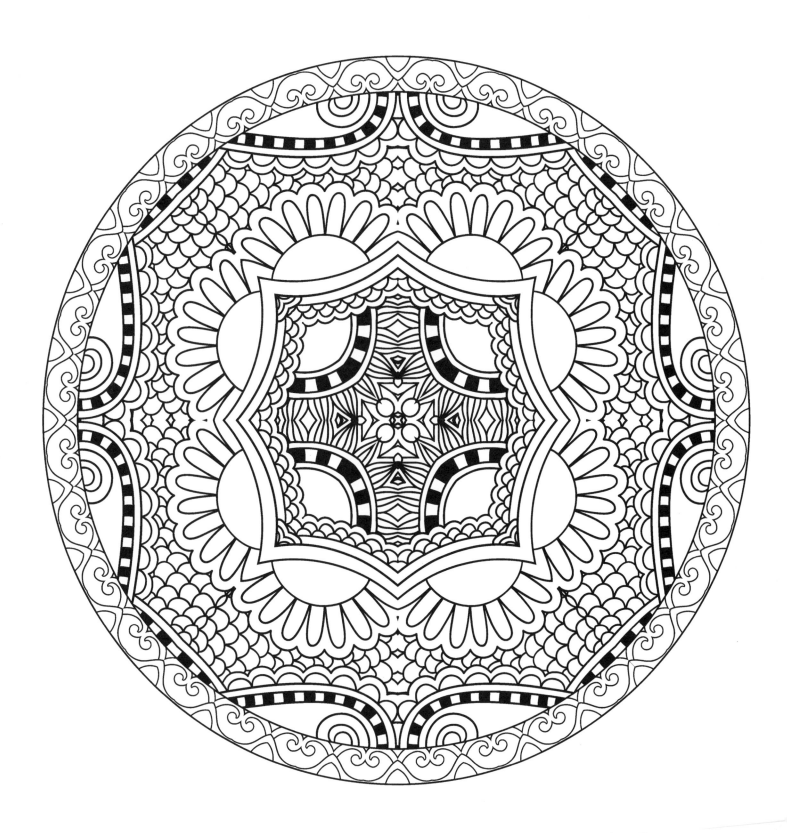

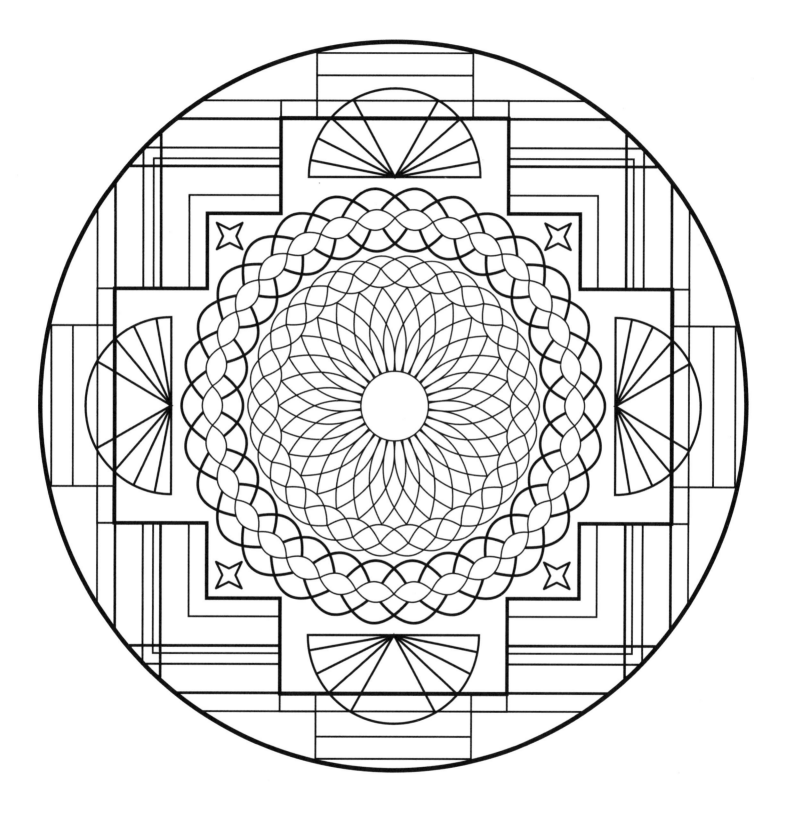

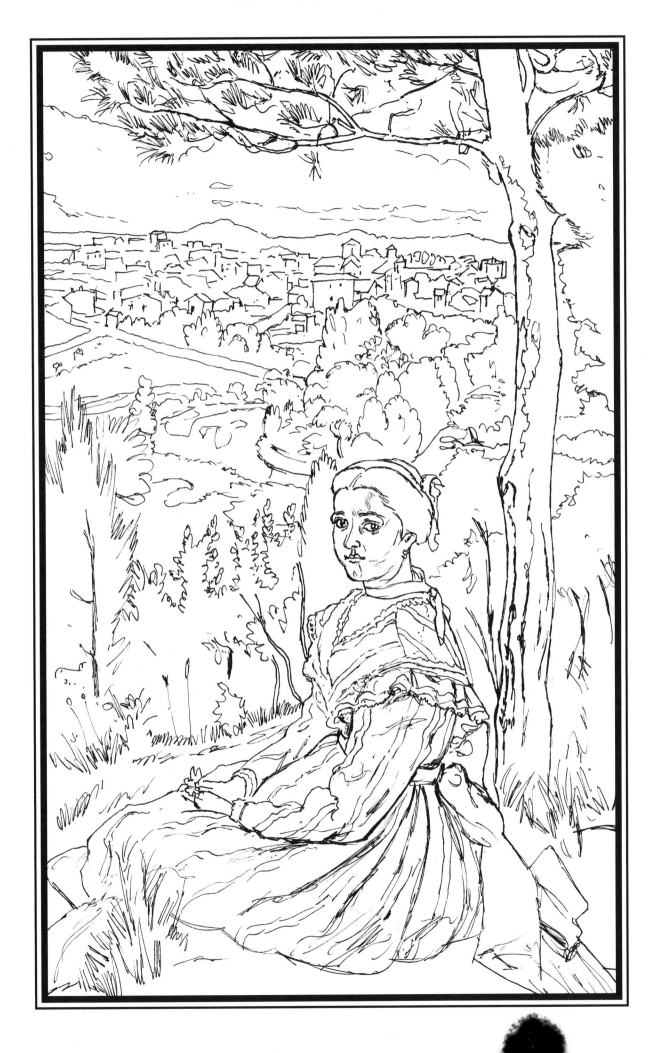

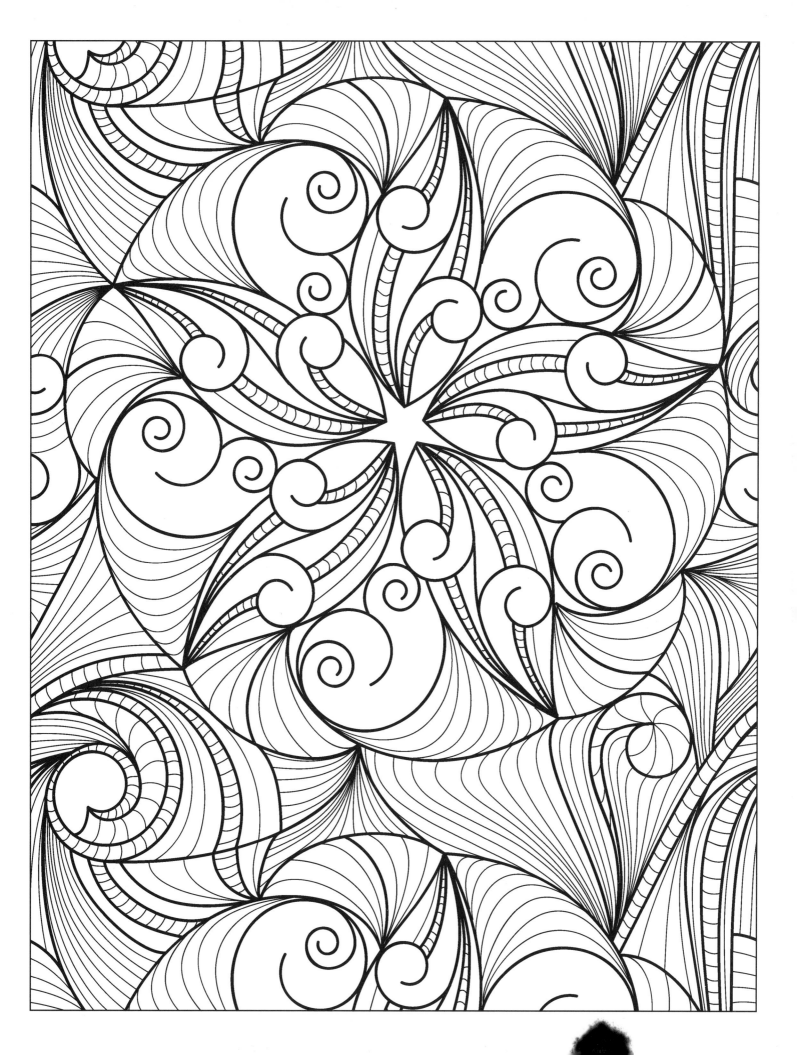

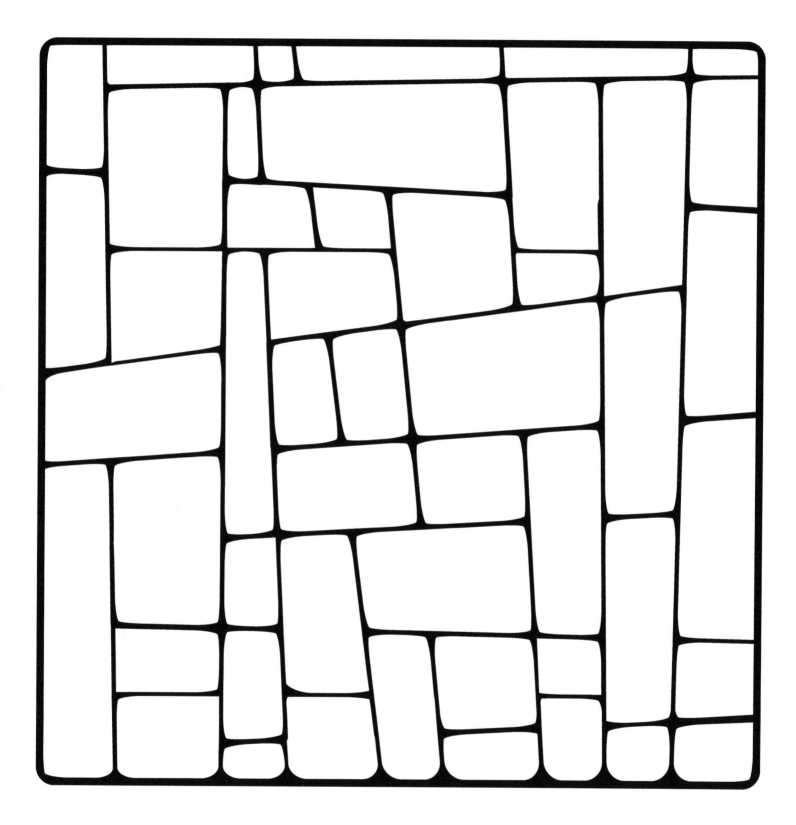

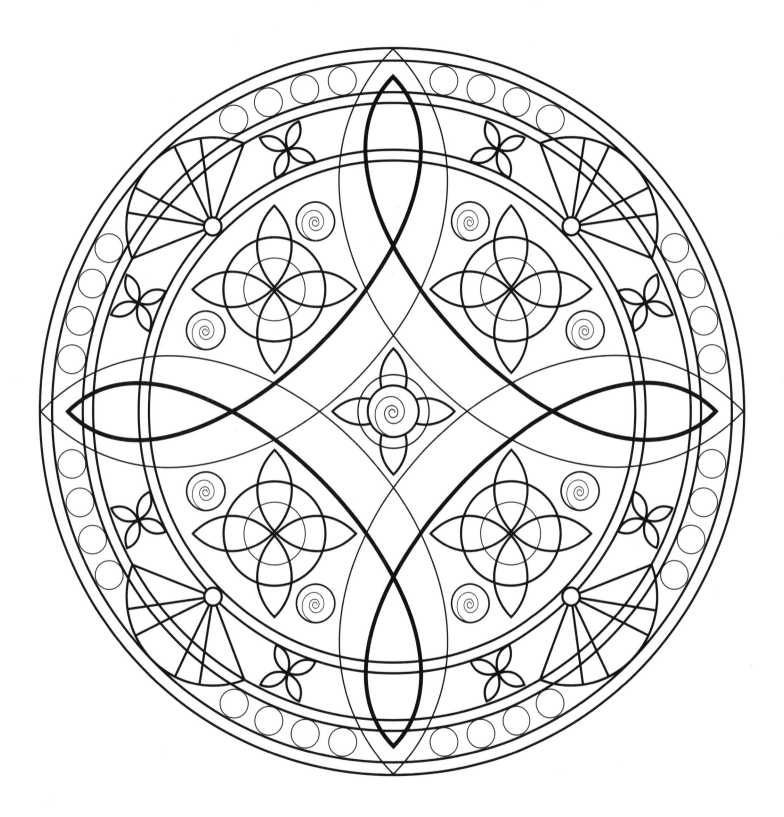

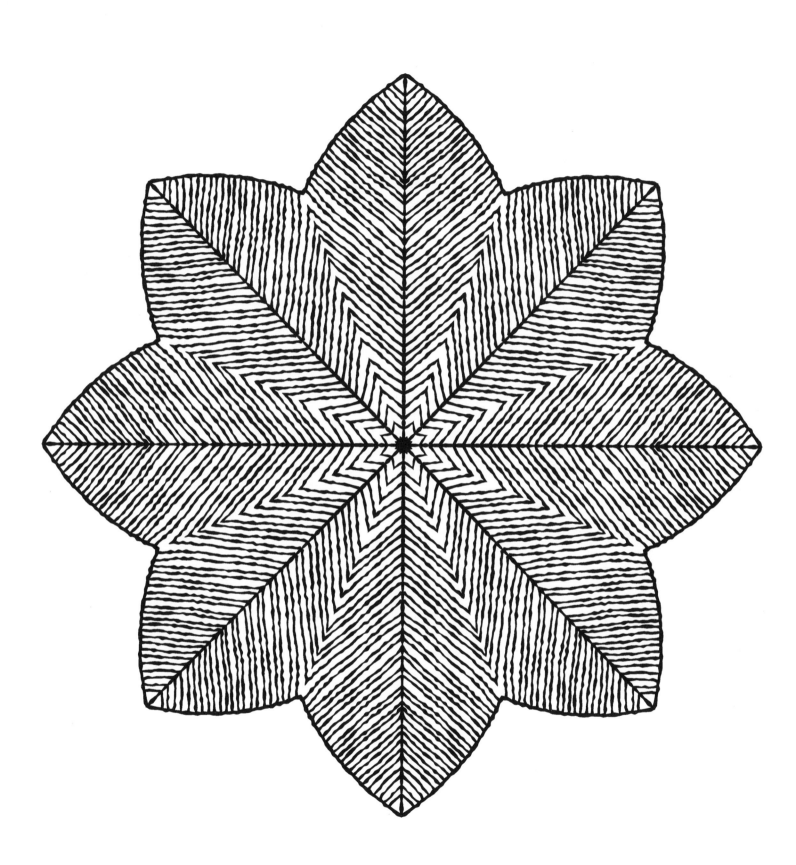

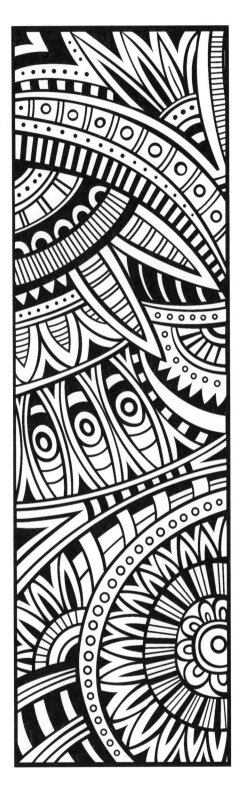
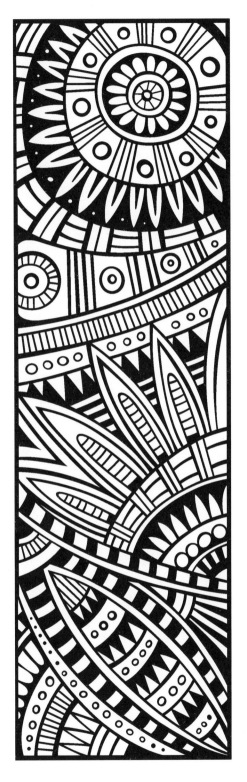

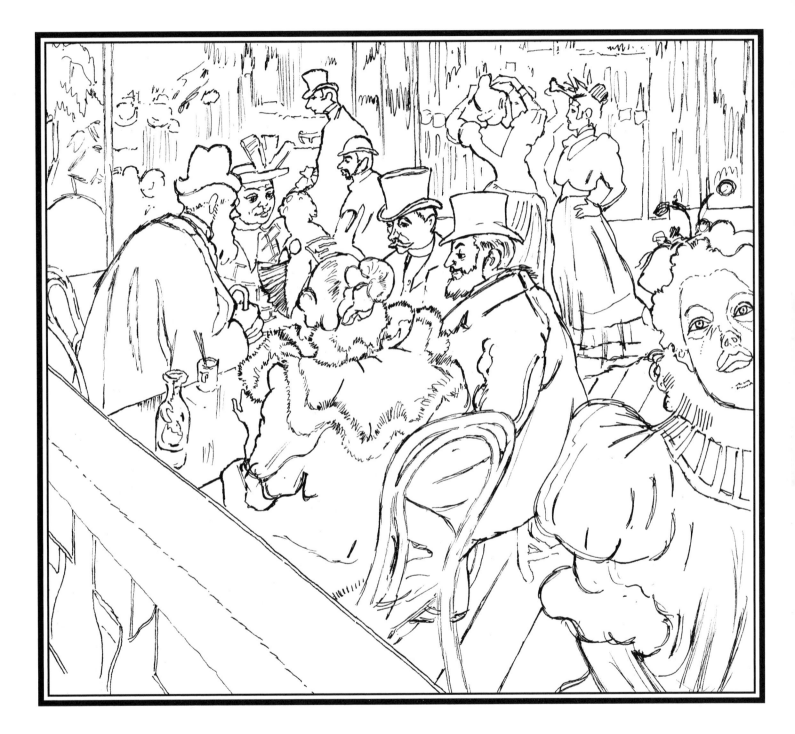

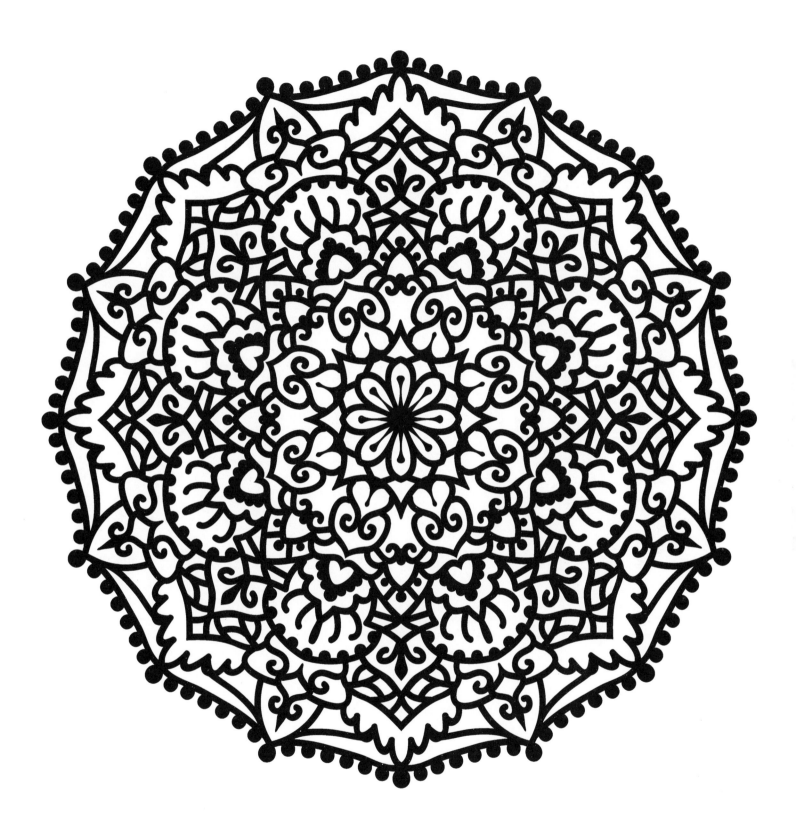

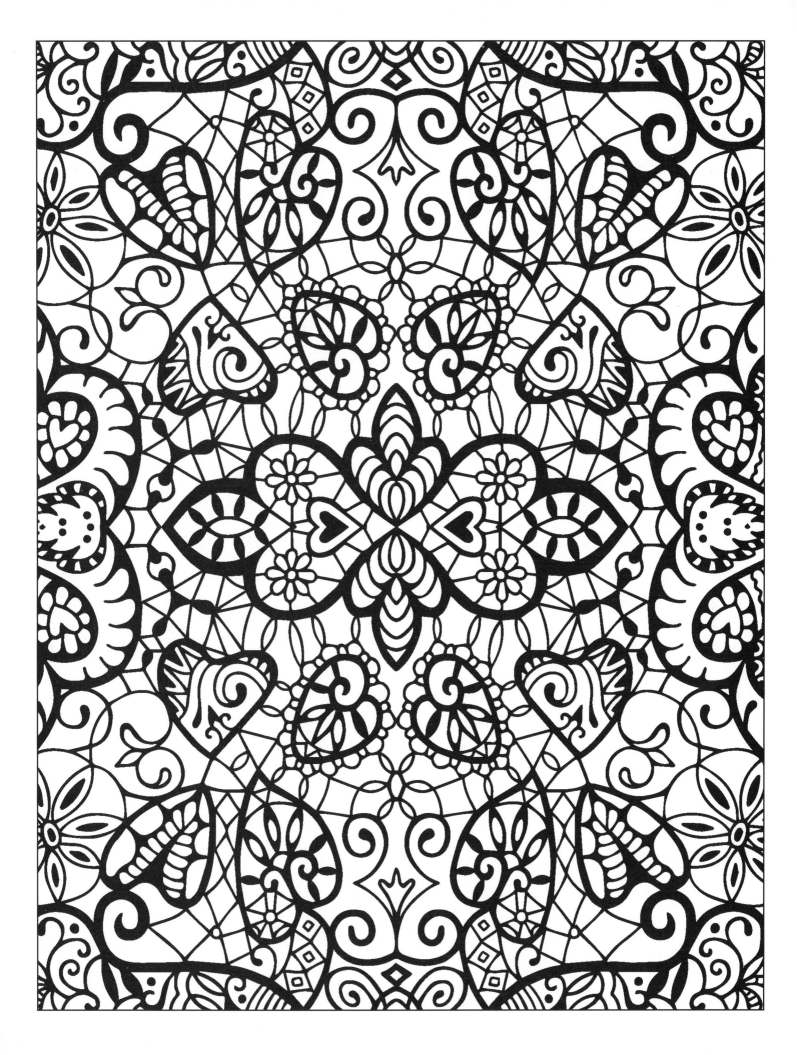

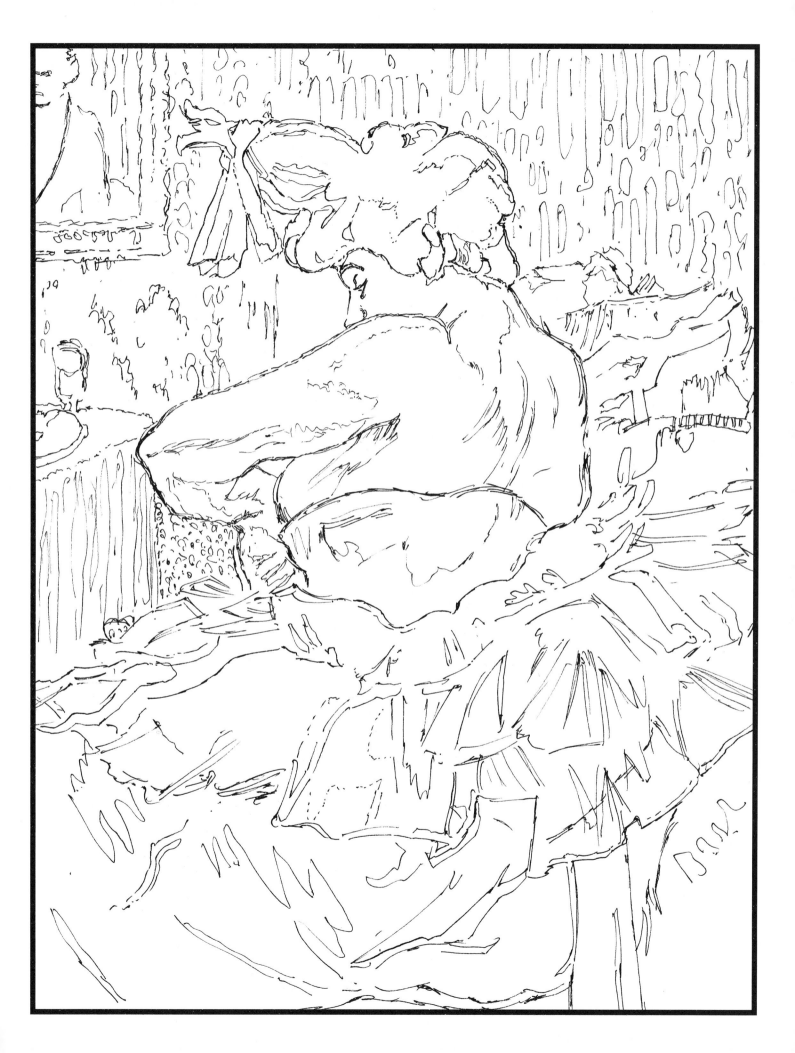

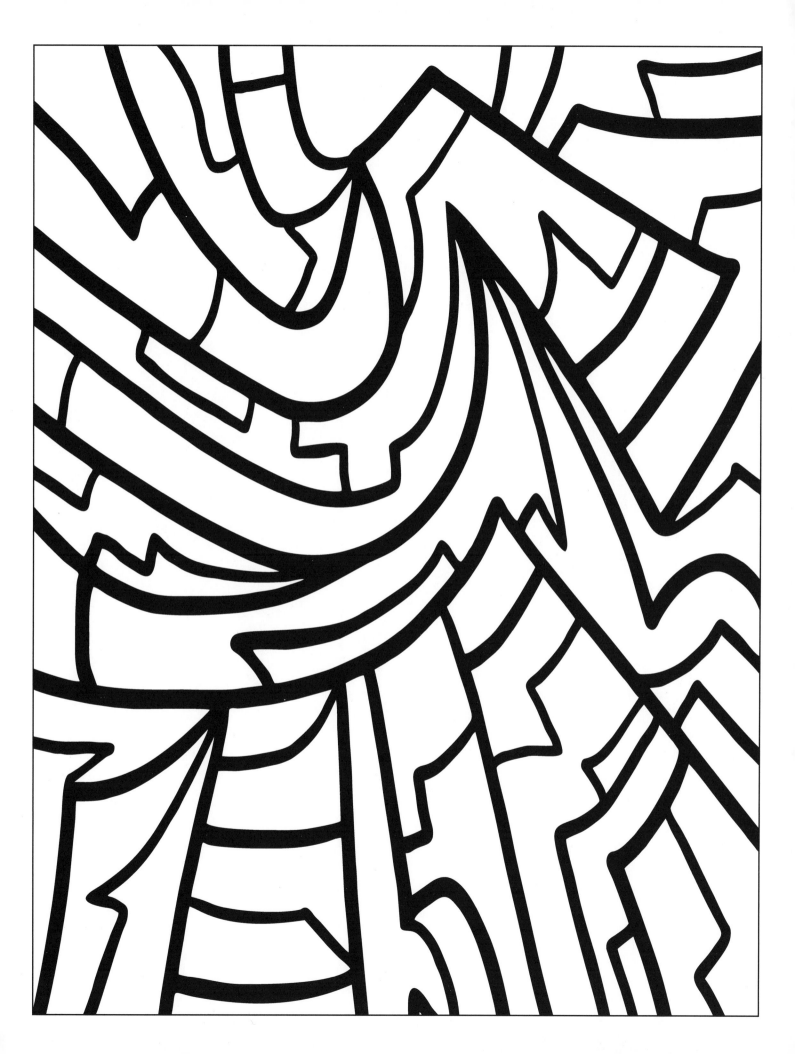

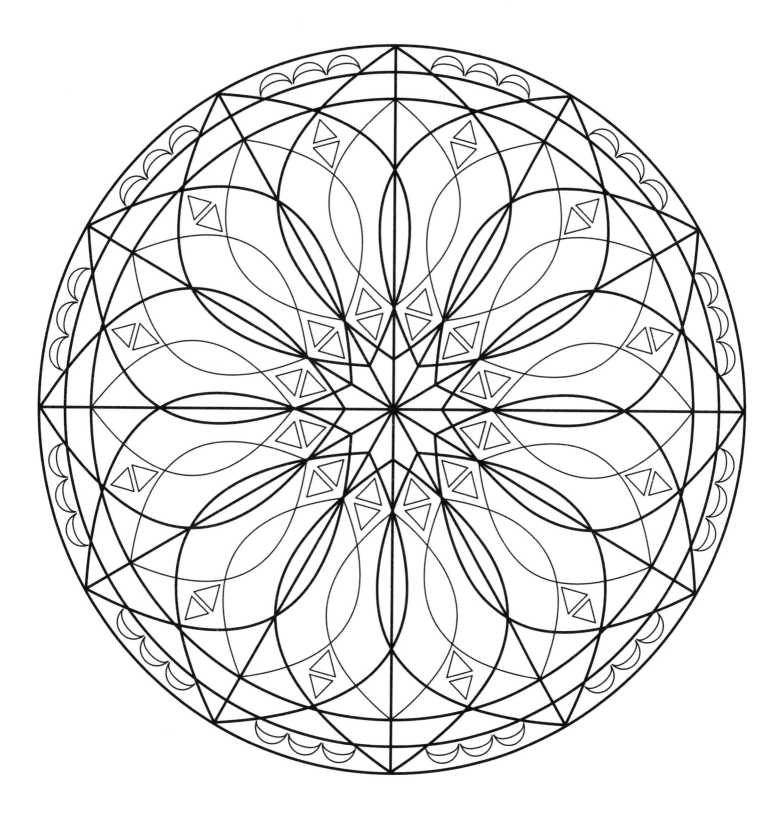

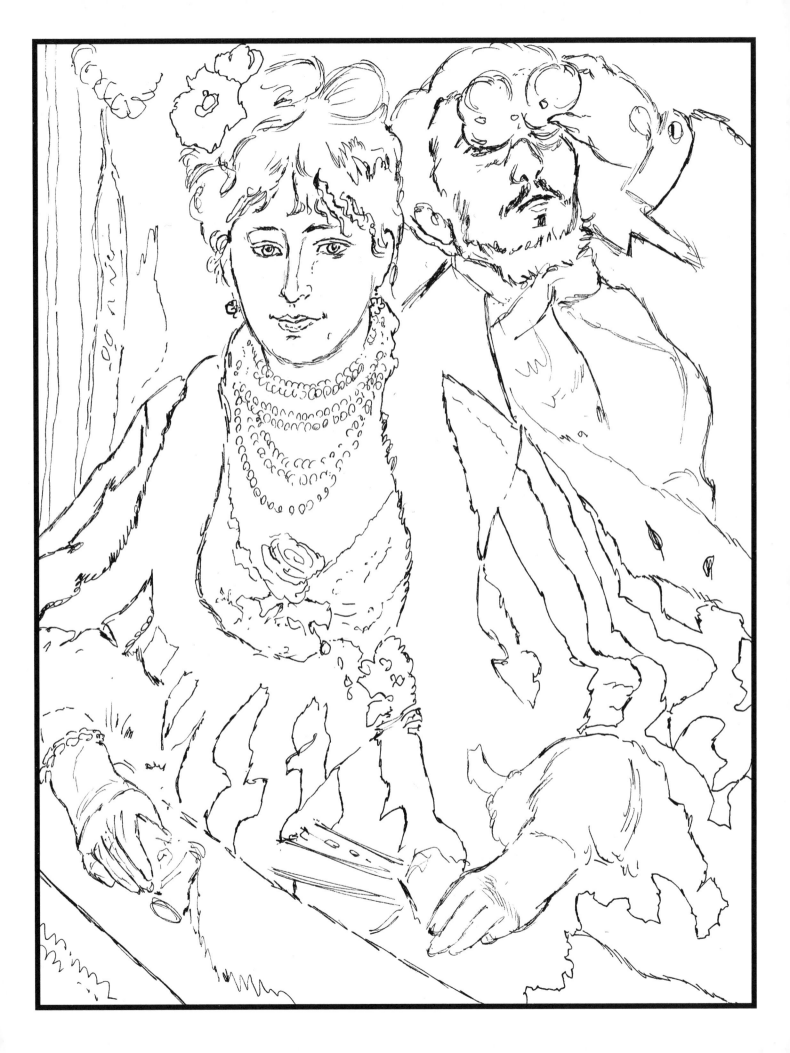

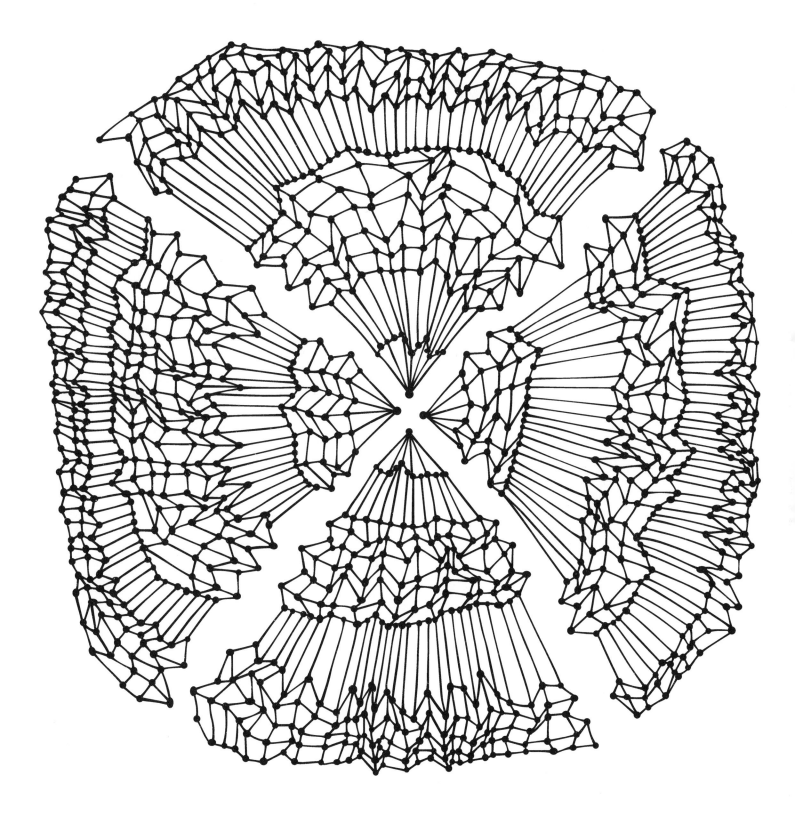

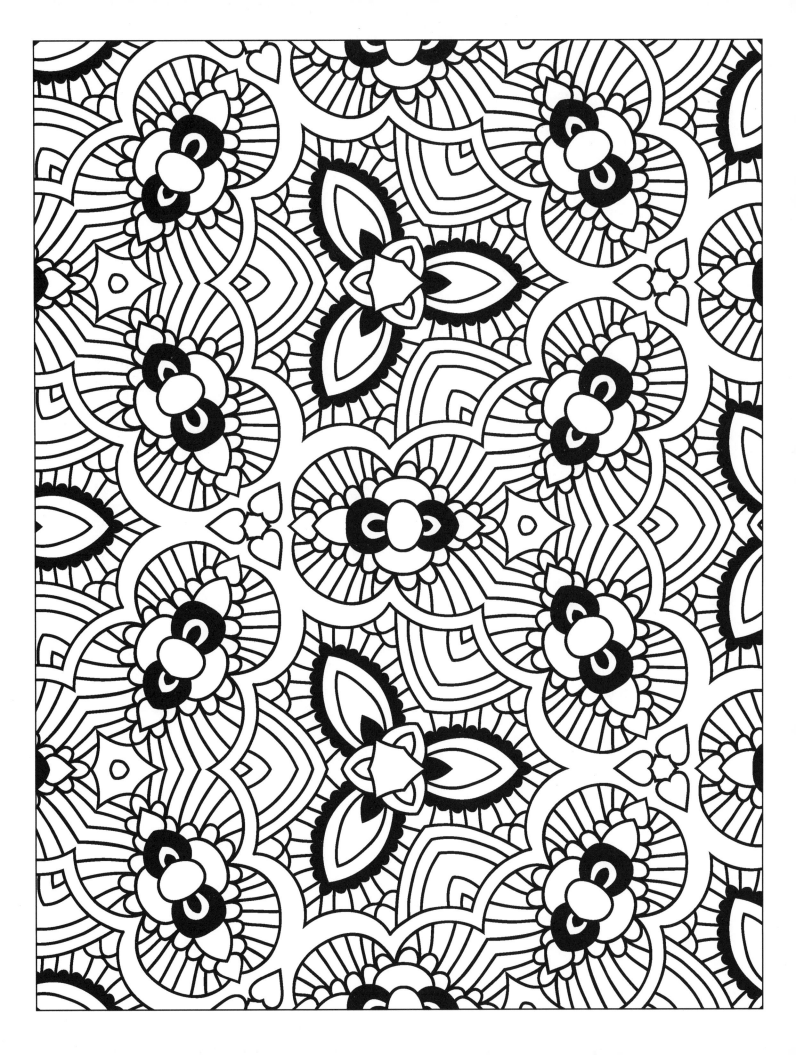

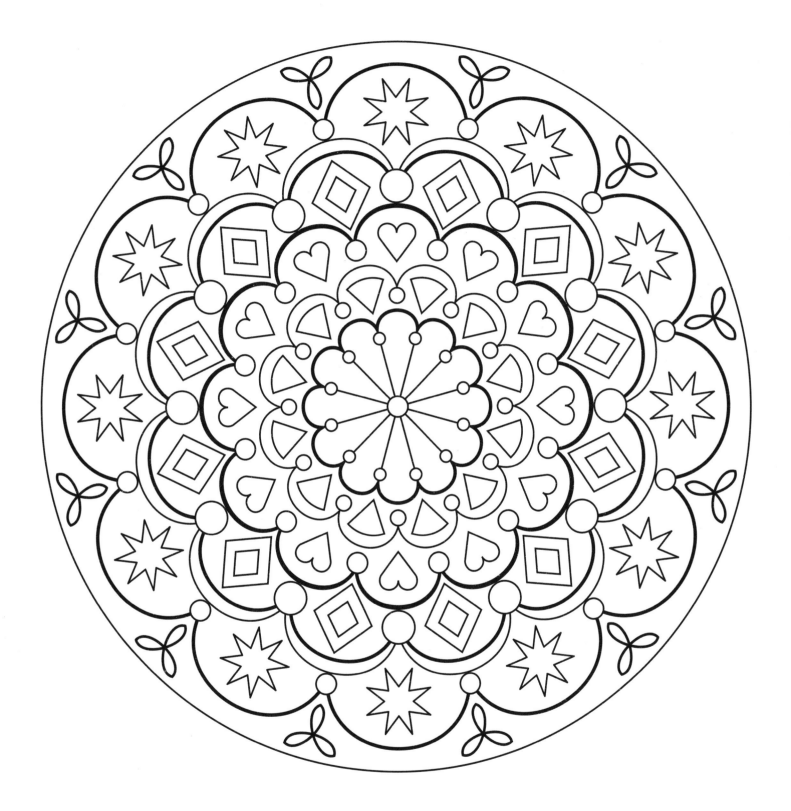

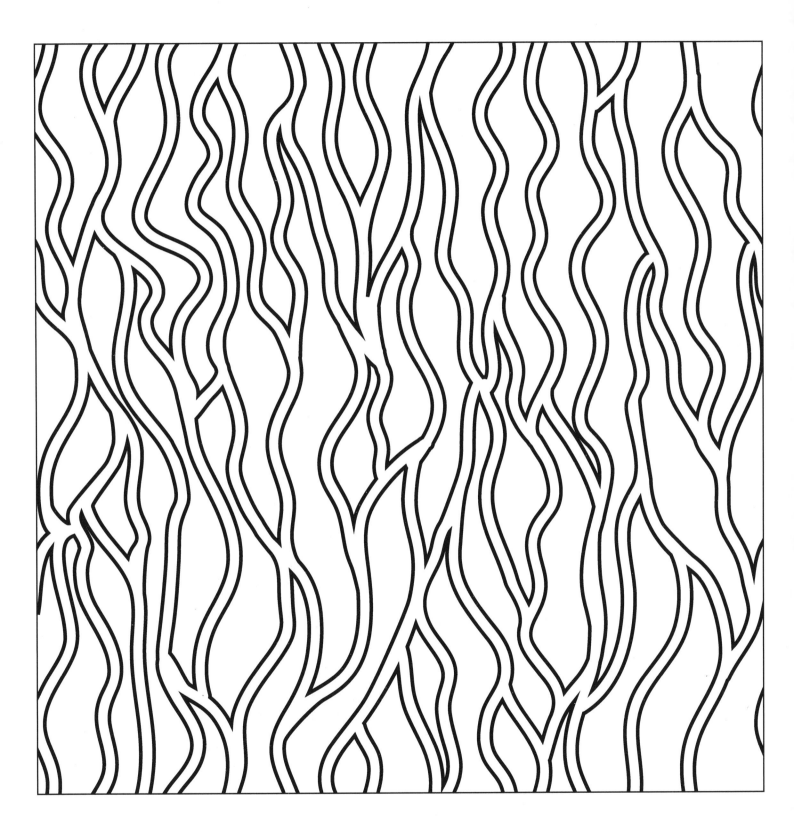

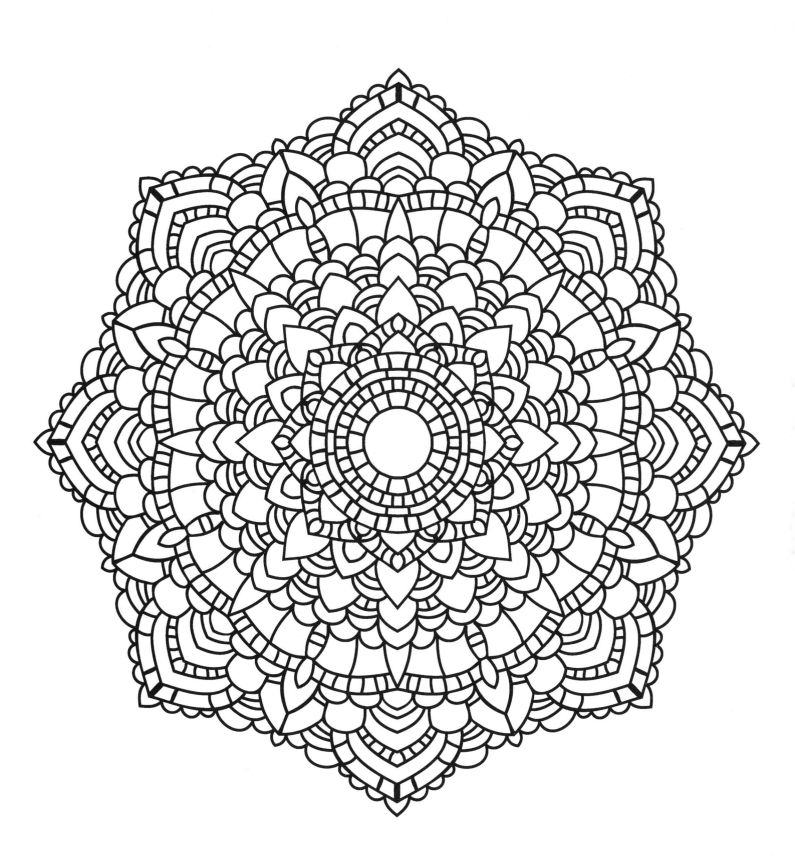

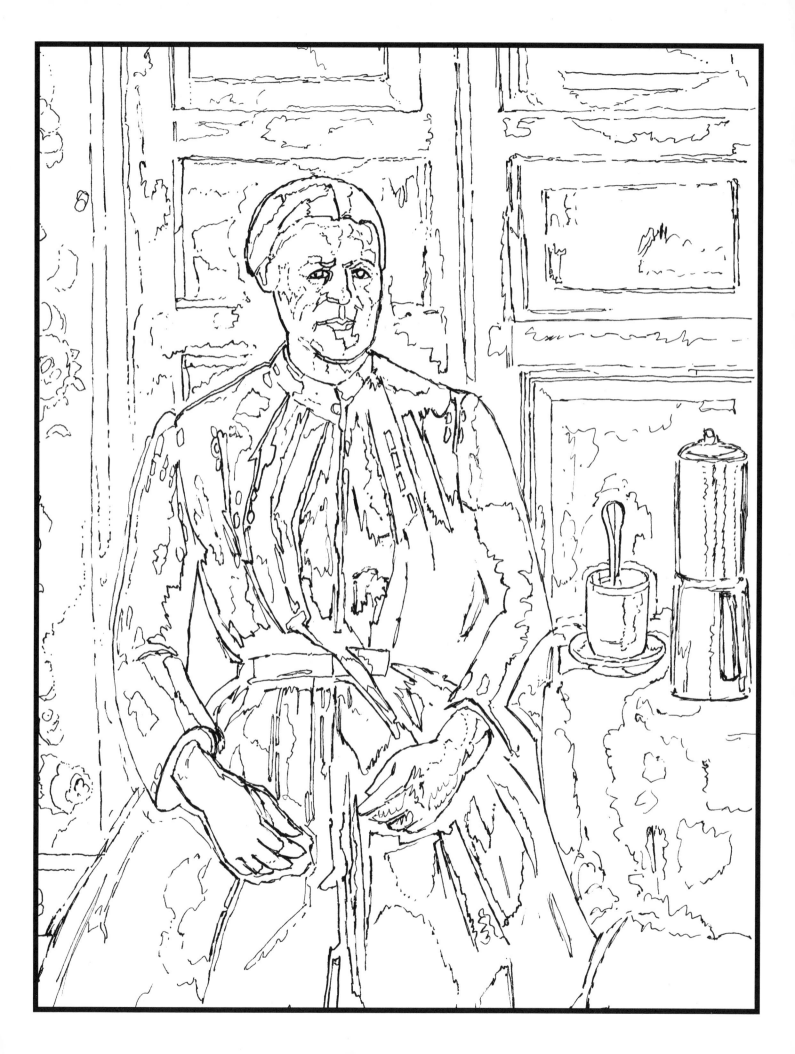

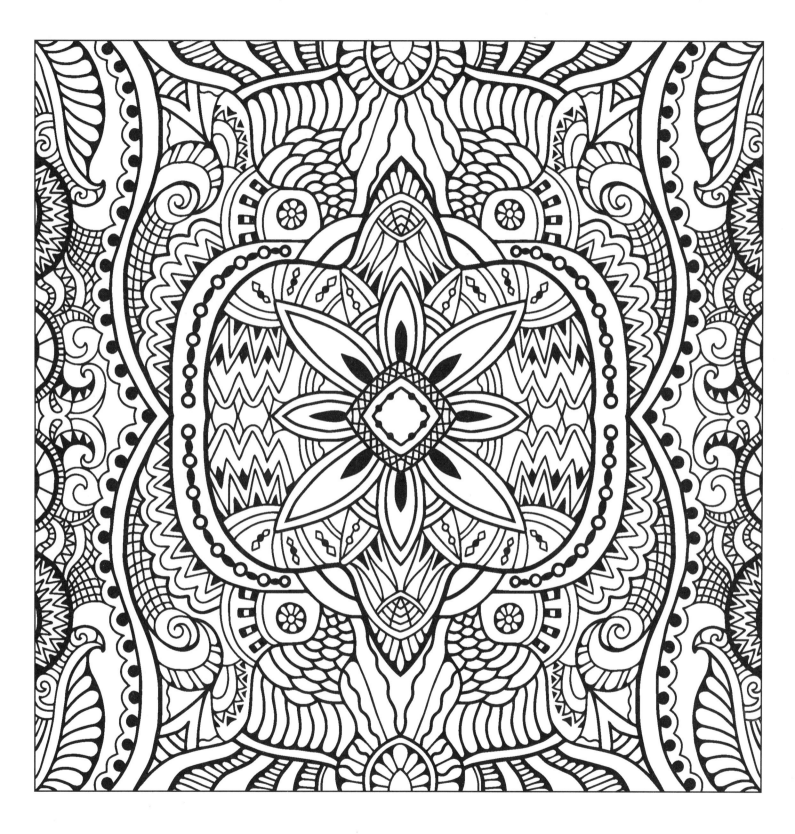

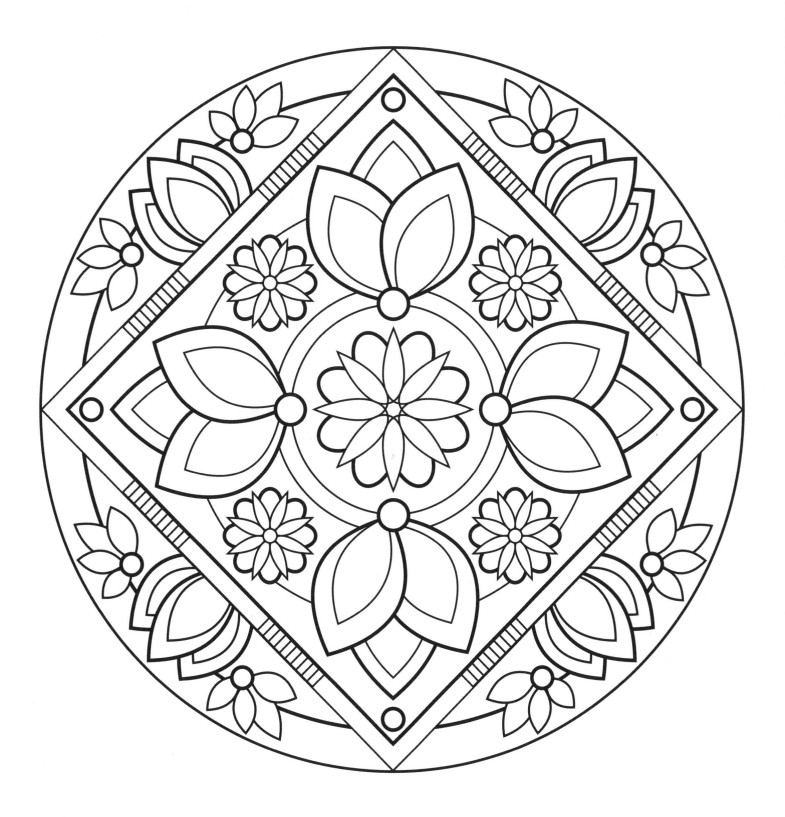

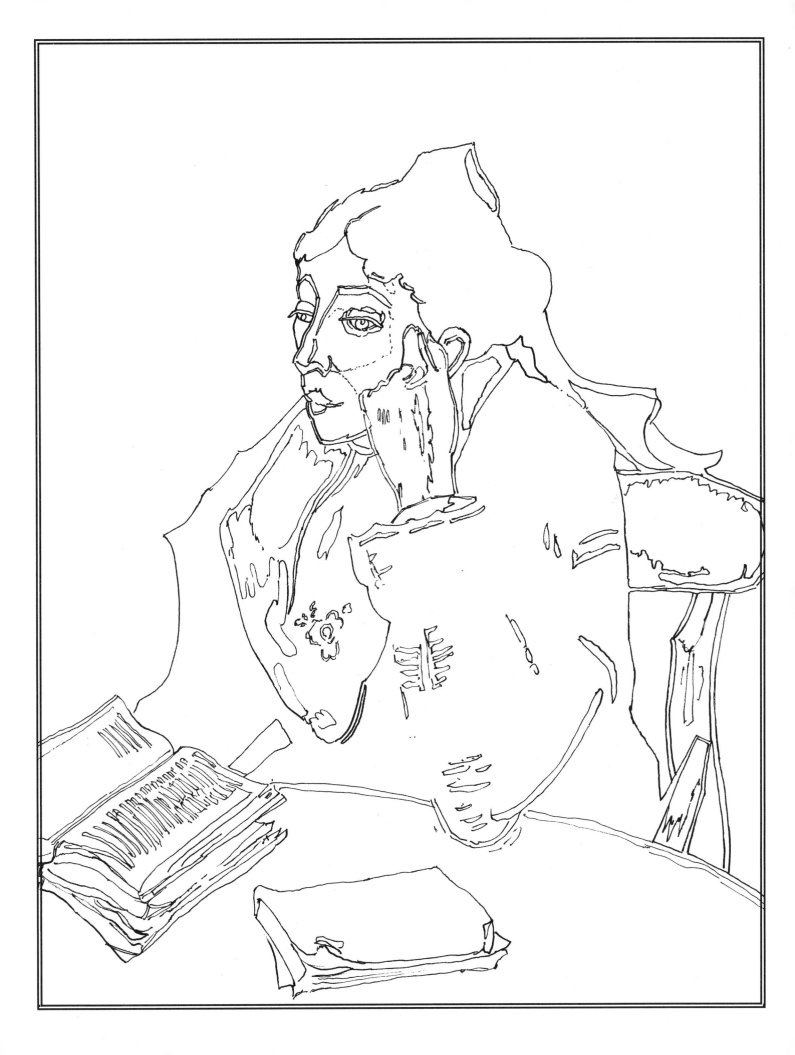

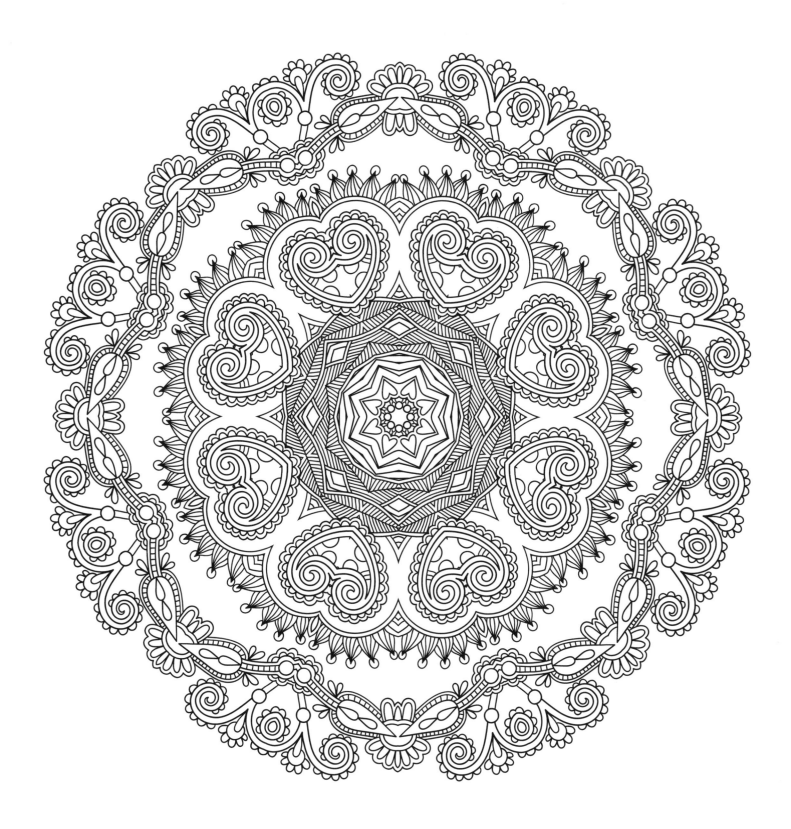

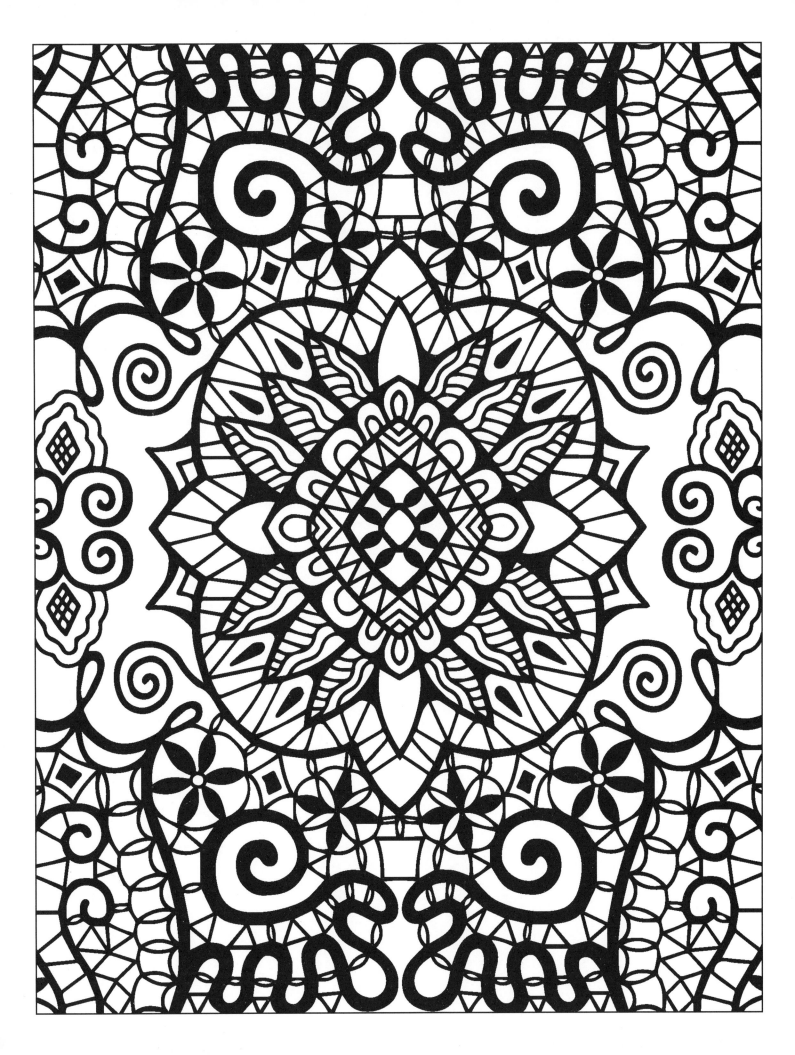

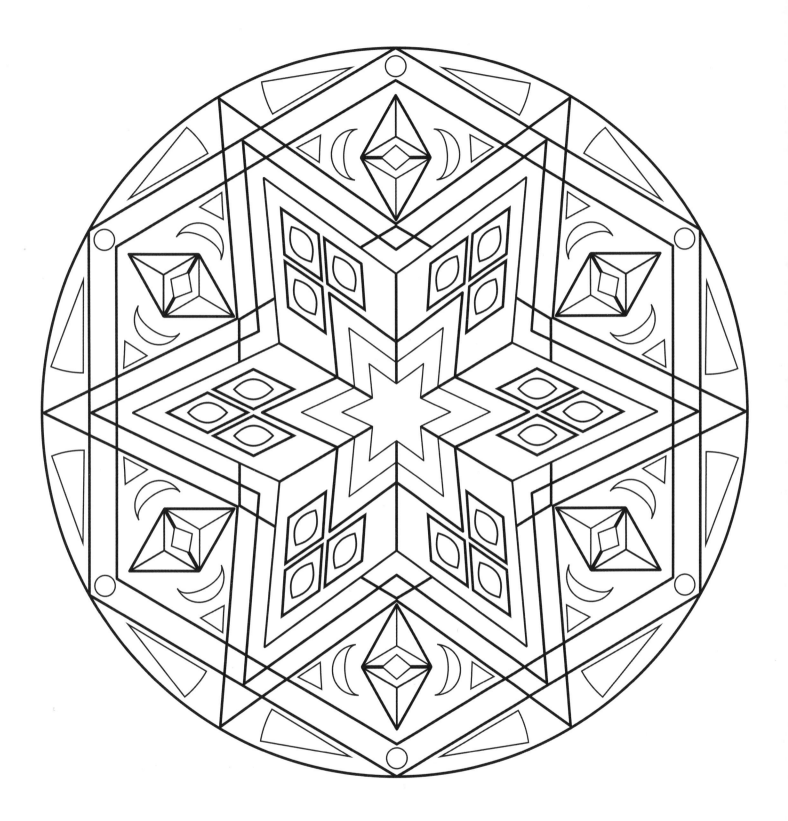

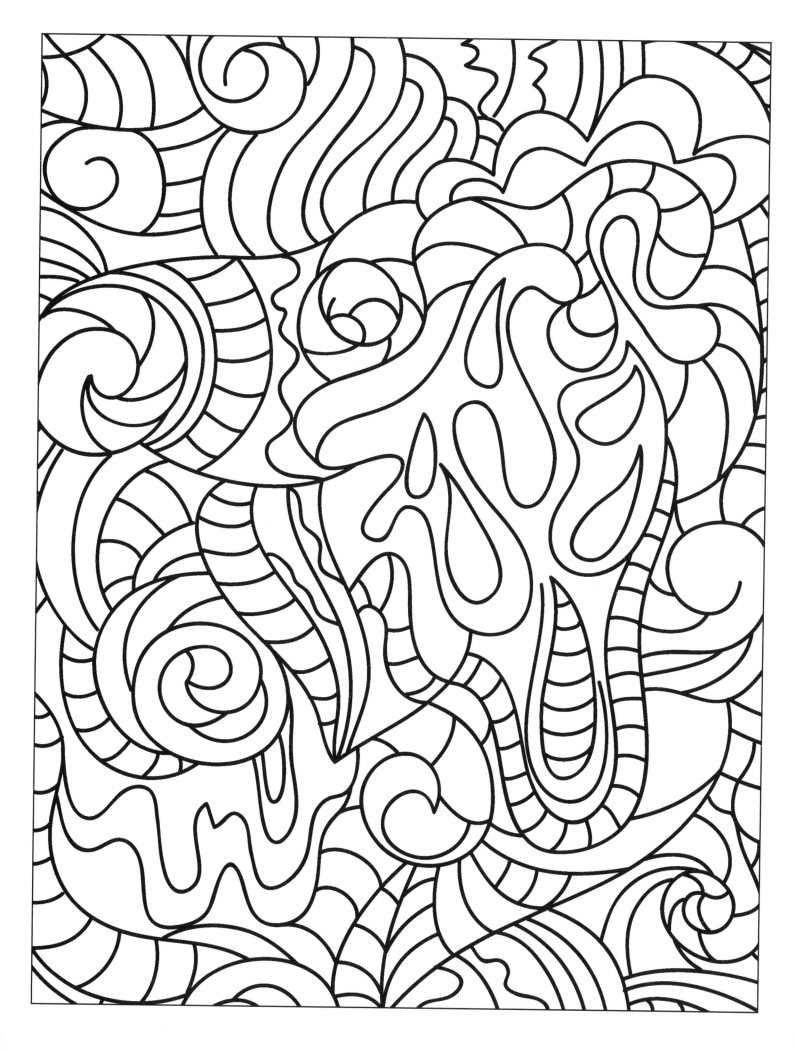

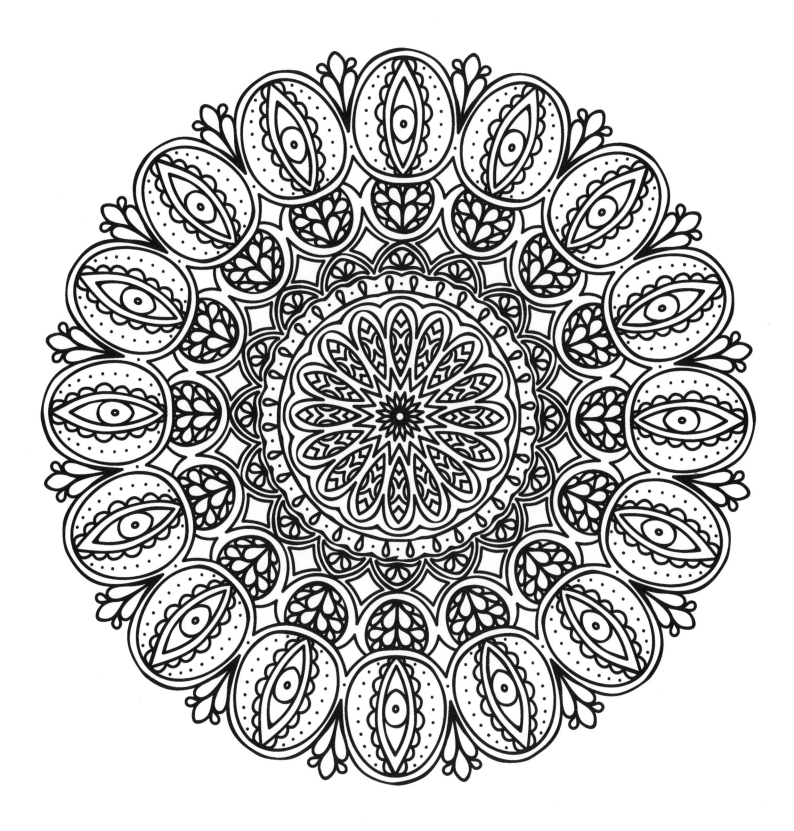

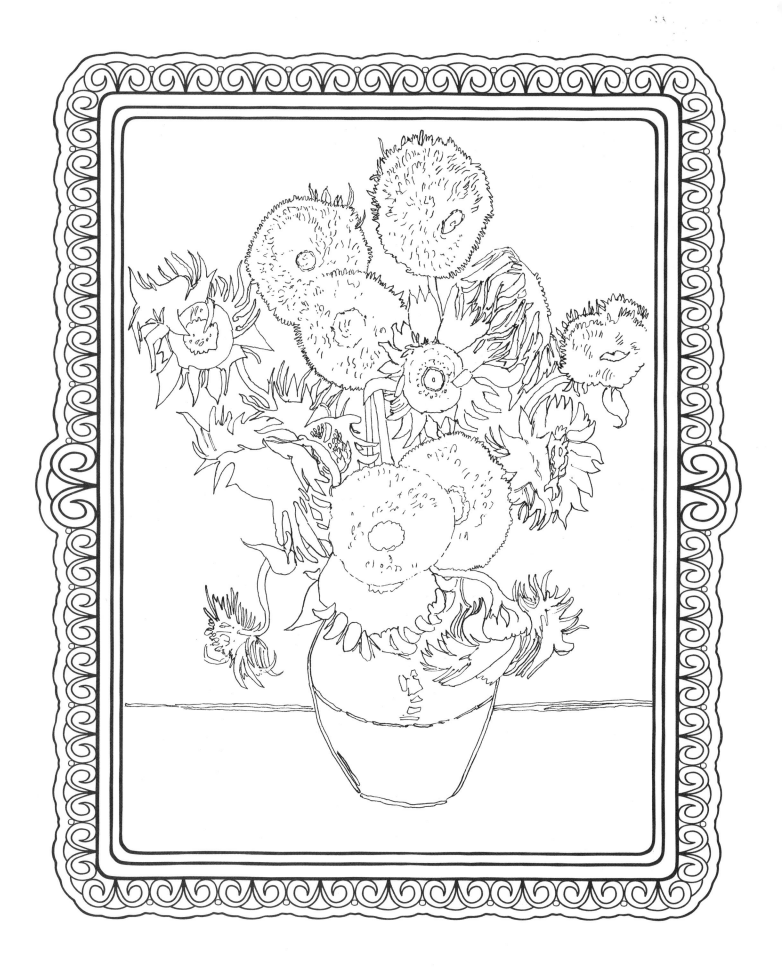

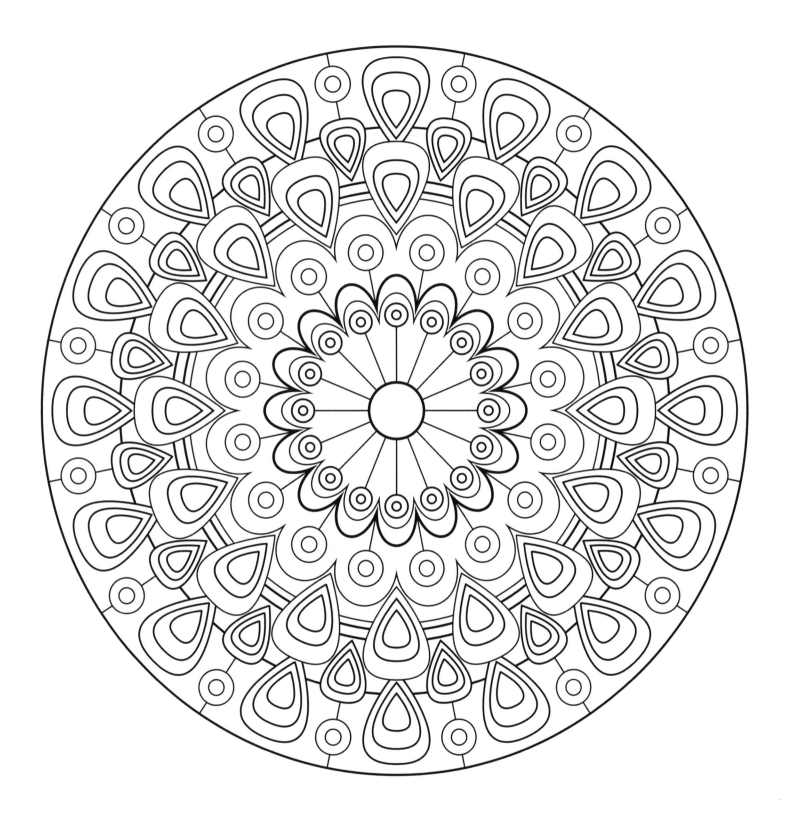

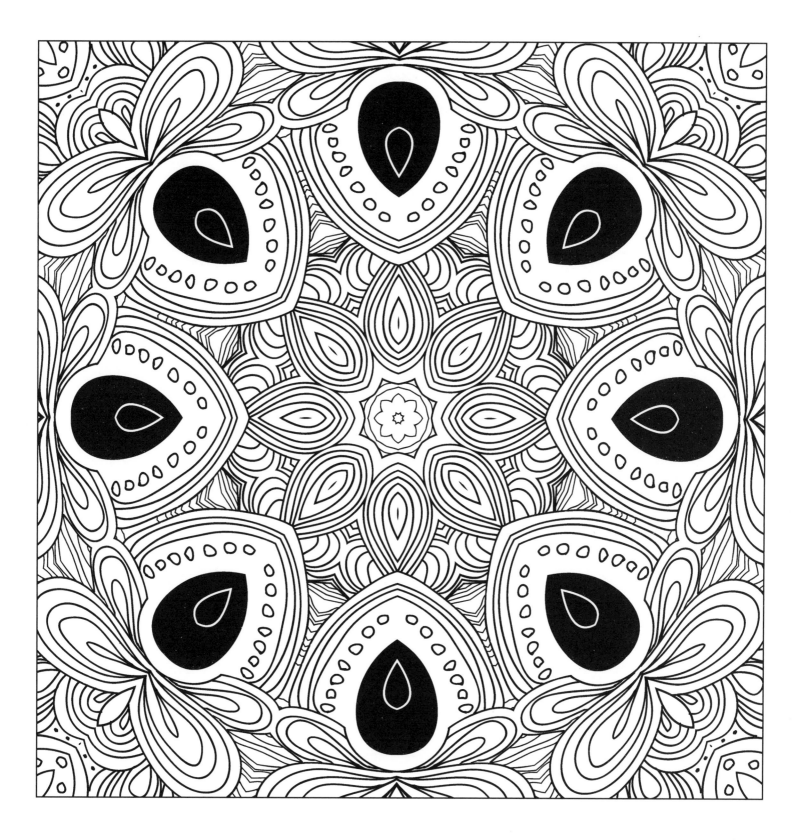

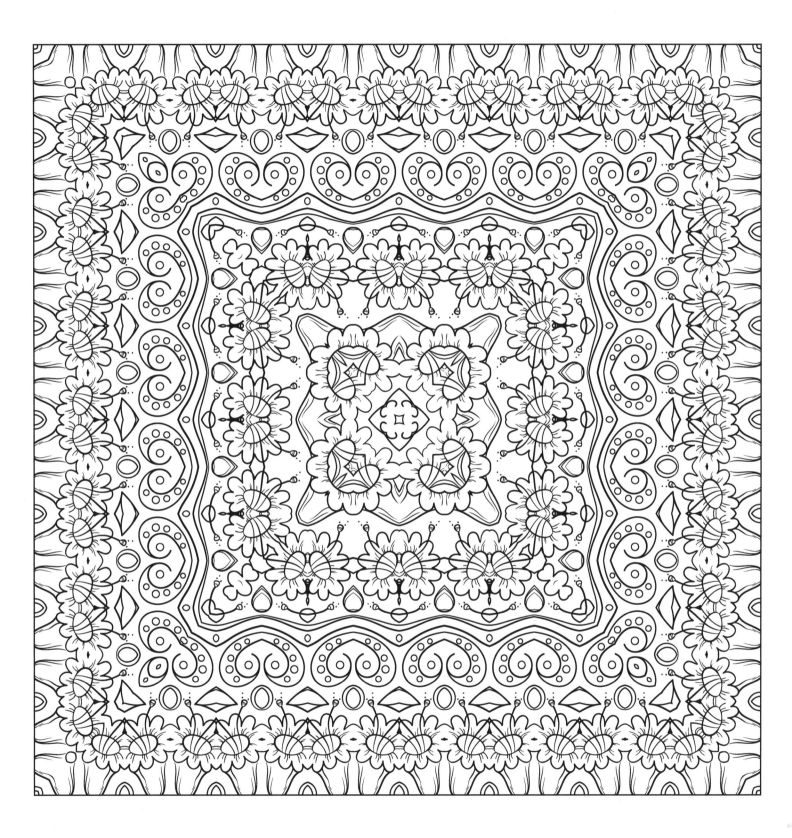

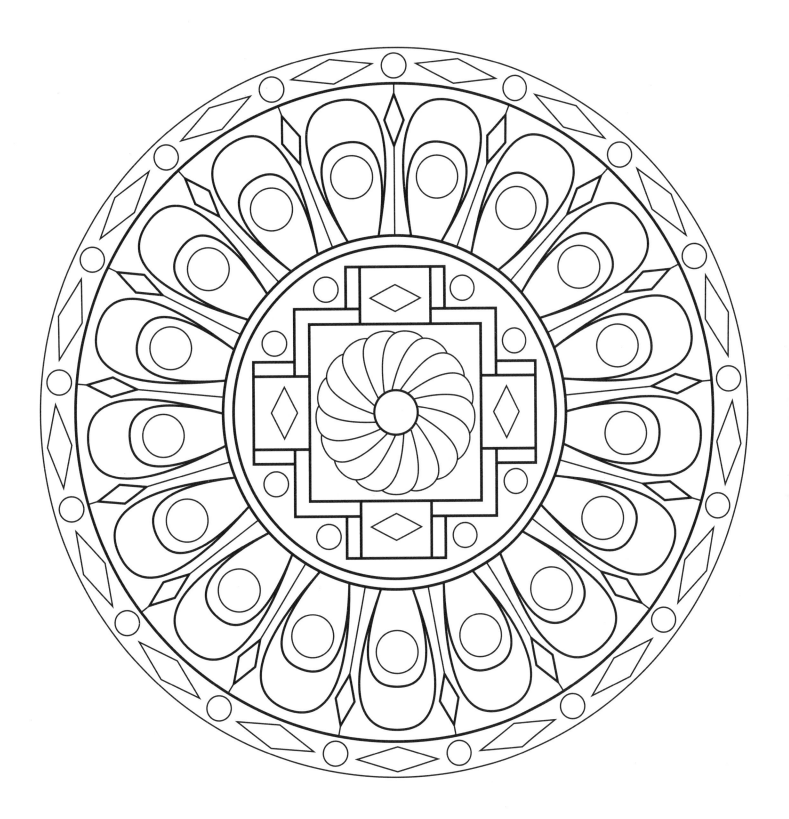

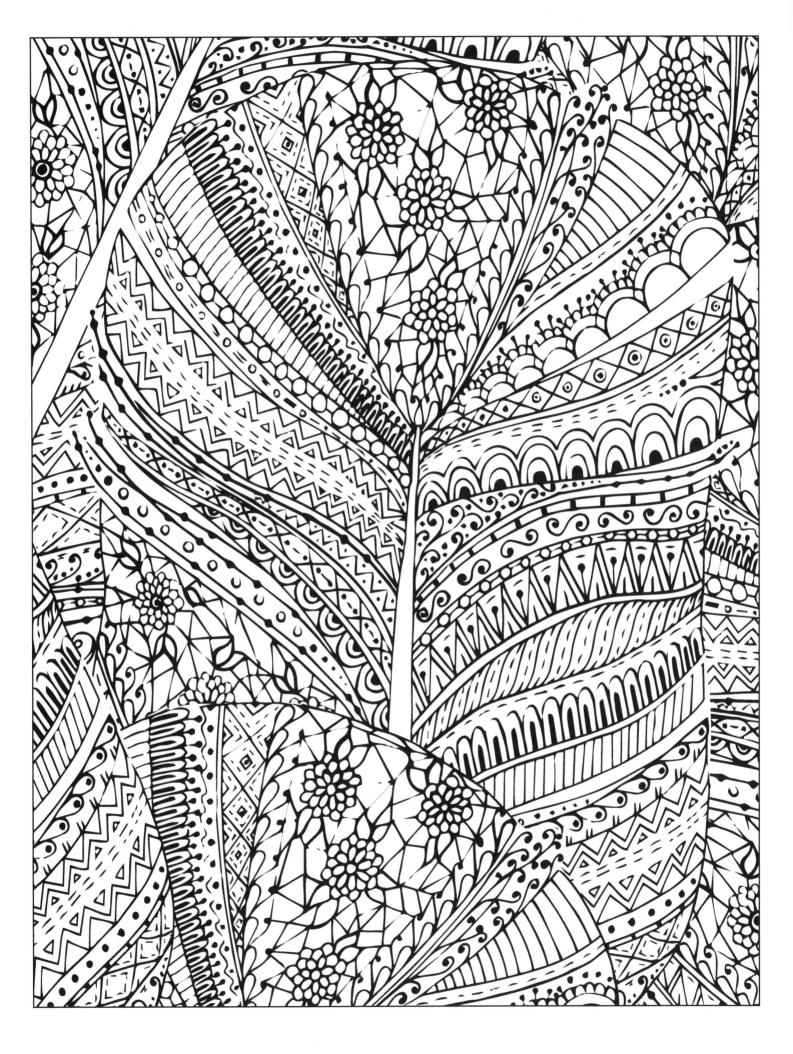

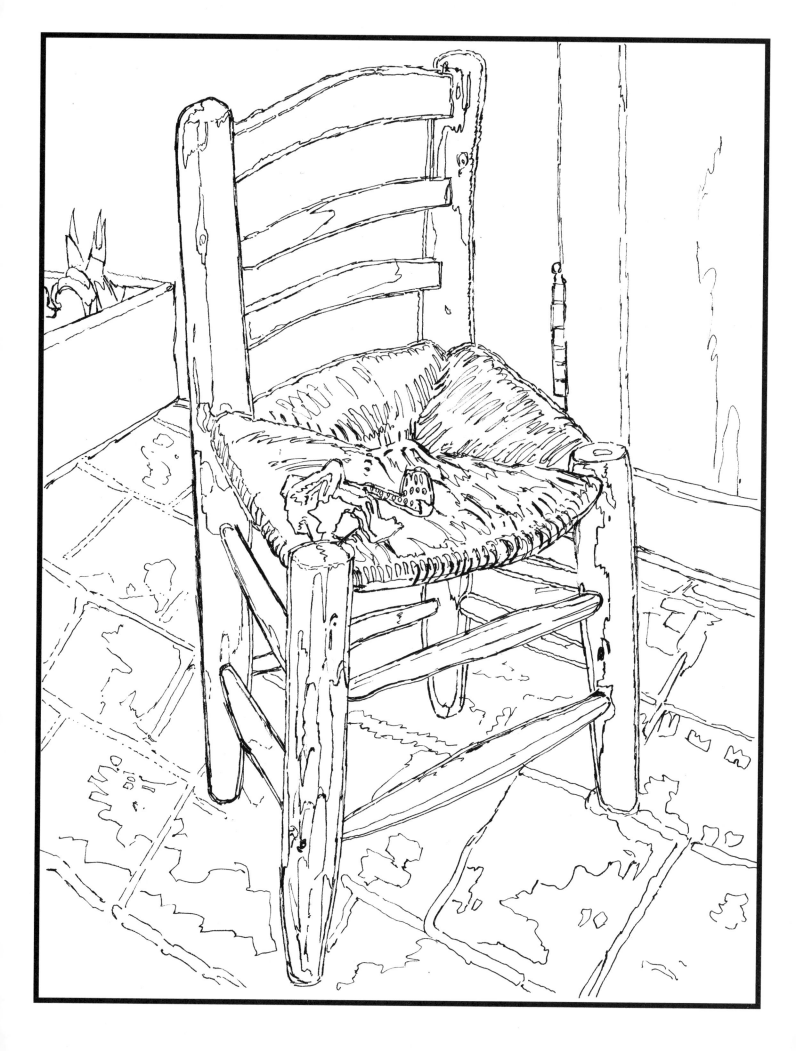

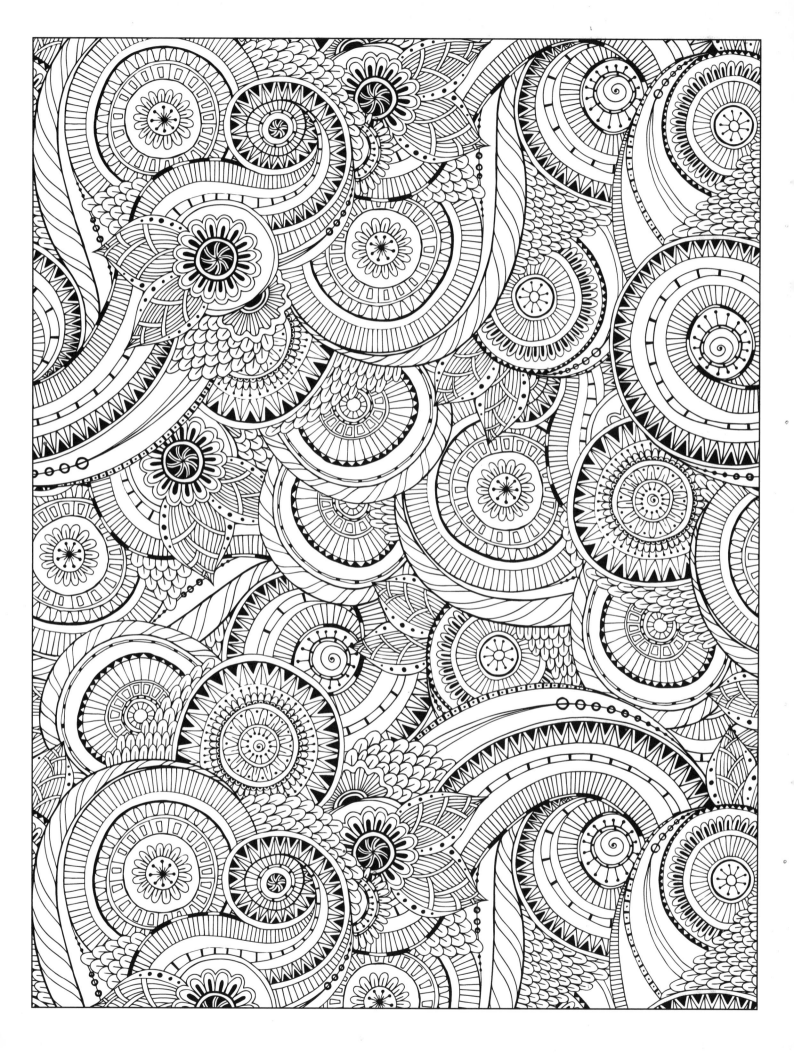

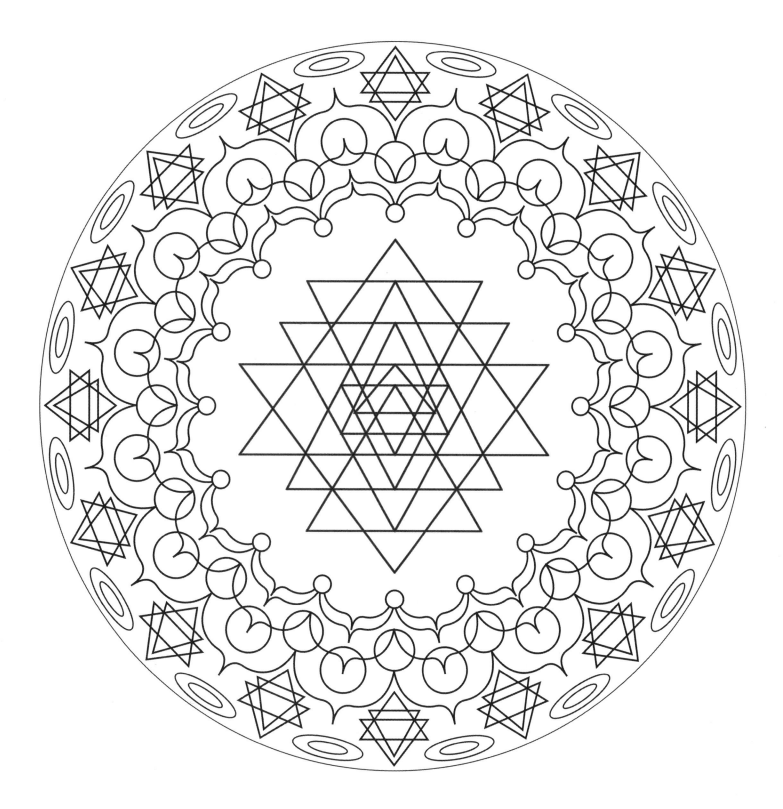

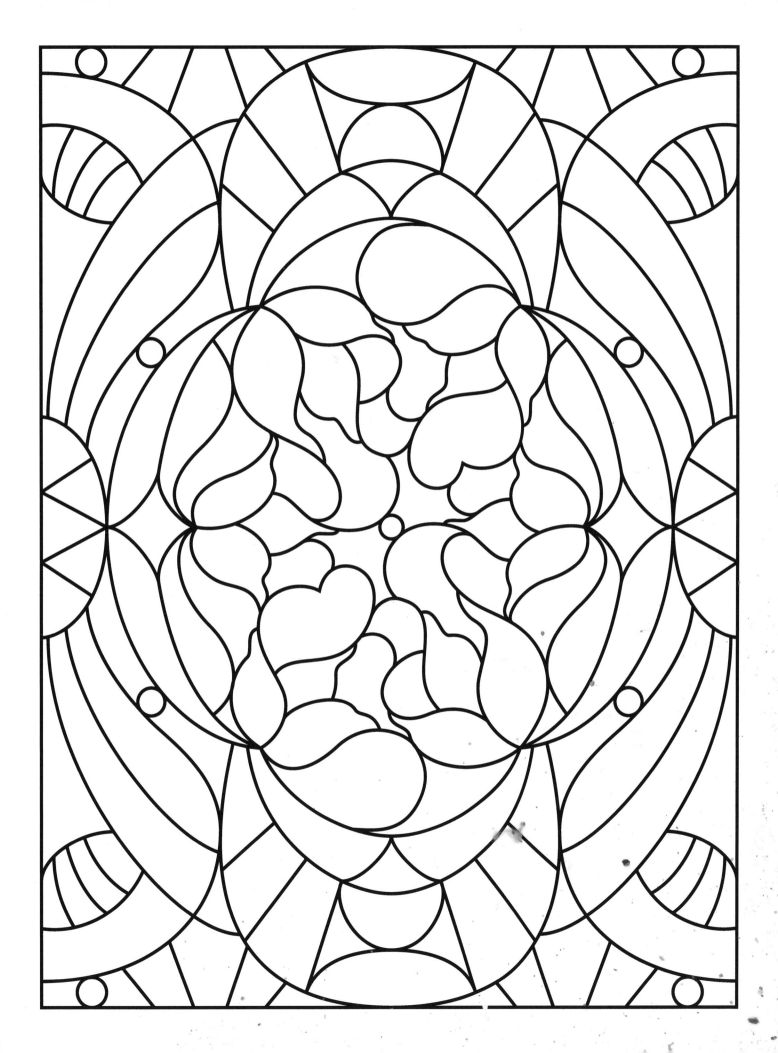

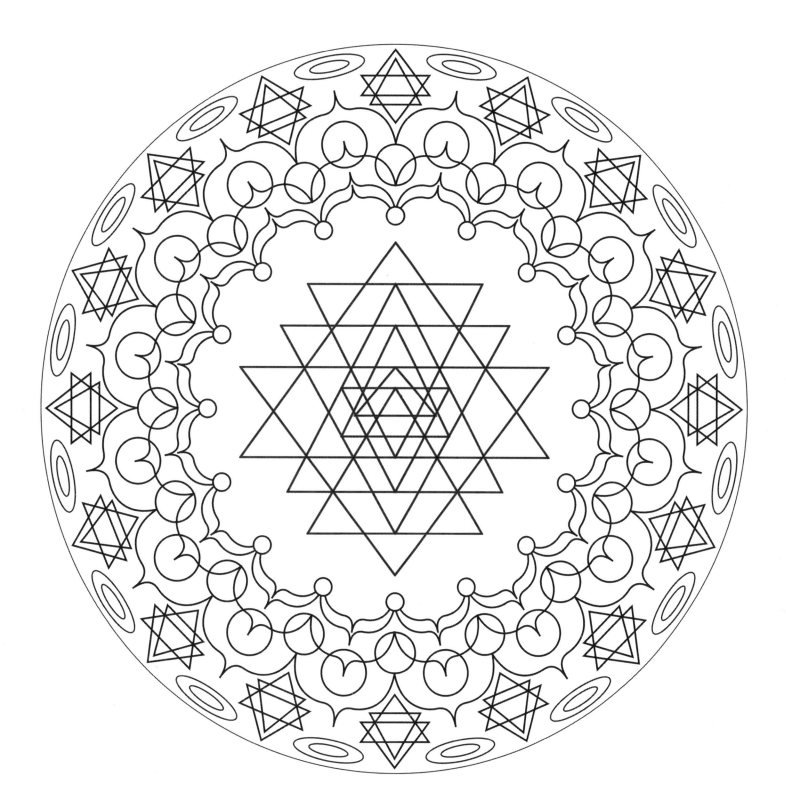

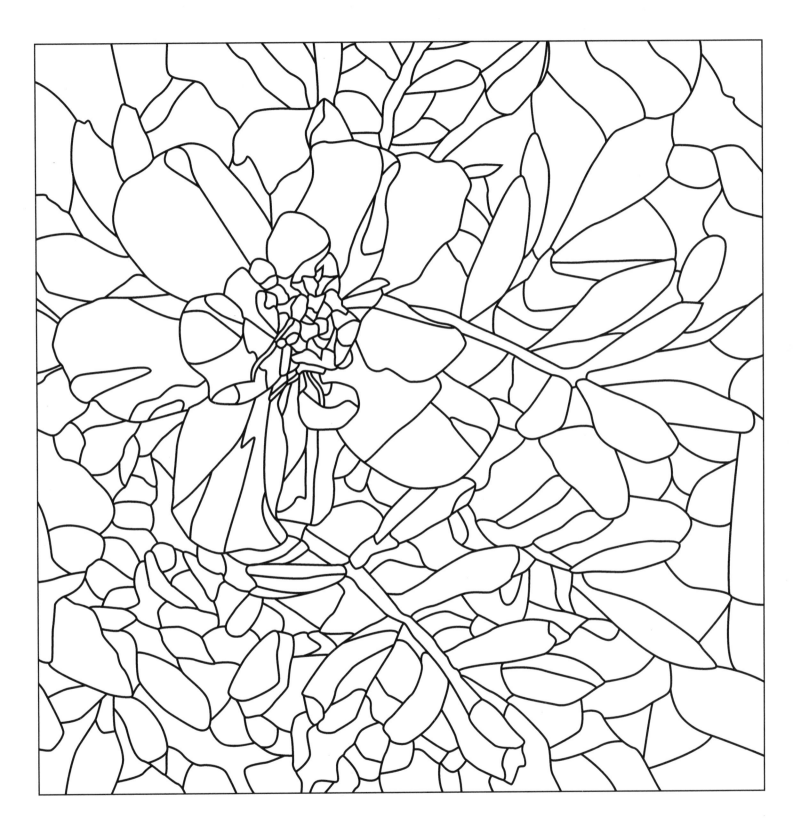

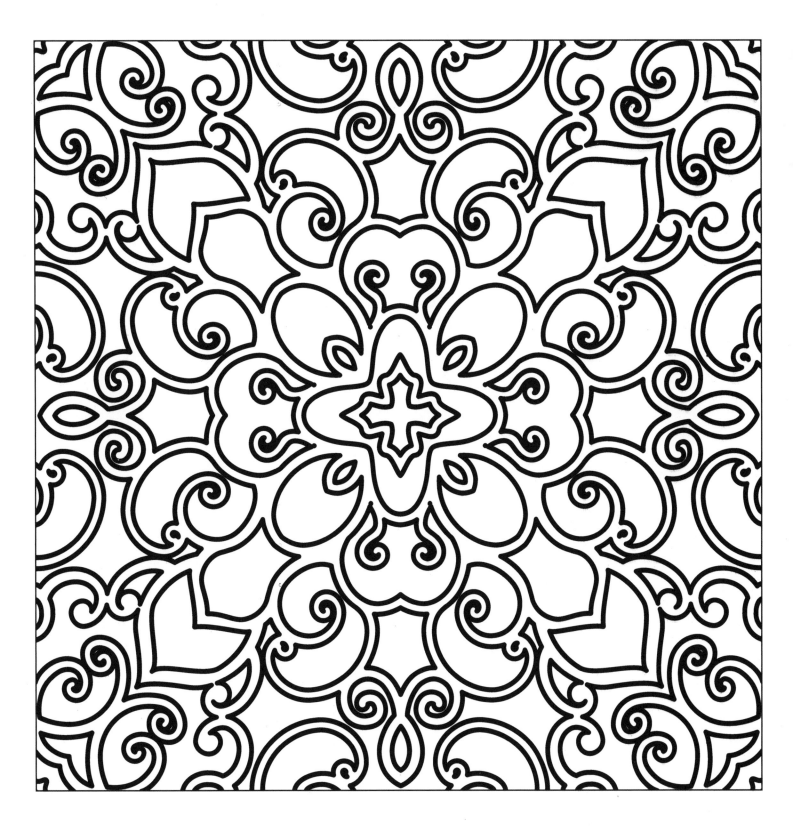

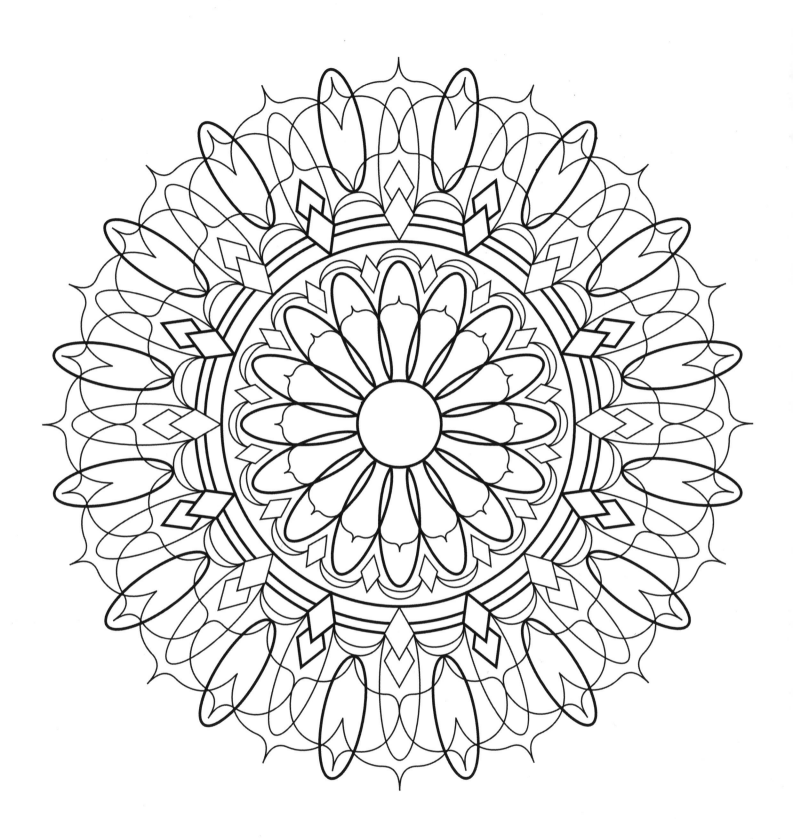